AUBURN
FOOTBALL

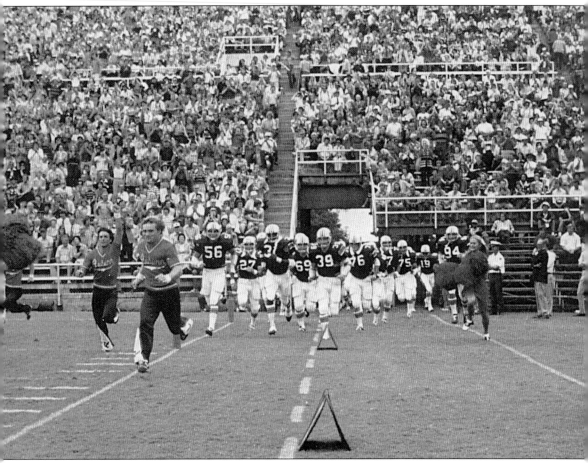

HERE COME THE TIGERS! The Auburn team traditionally makes a dramatic entrance from the end zone onto the field before games. Beginning in the 2000 season, players, coaches, and staff run through manufactured smoke to intensify team and fan spirit and psyche out opponents.

On the front cover:
Coach Michael "Iron Mike" Donahue and his coaching staff are pictured with the 1915 Auburn team. Because so many Auburn star players had graduated, Donahue "developed for Auburn a truly wonderful team from a mass of green material." The 1915 Tigers, determined to "staunchly uphold the honor of the Orange and Blue on the gridiron," won the season's first game 76-0 against Marion played at Selma. Overall, they had a 6-2 record, beating main rival Georgia 12-0 at Athens. Auburn also defeated Florida 7-0 at home. Donahue later coached undefeated and Southern Championship teams and pioneered plays such as the forward pass. He was the first Auburn person inducted into the College Football Hall of Fame. Auburn's Donahue Drive, named for him, is appropriately located next to Jordan-Hare Stadium.

AUBURN
FOOTBALL

Elizabeth D. Schafer, with foreword by Liston Eddins

ARCADIA
PUBLISHING

Published by Arcadia Publishing
Charleston, South Carolina

Printed in the United States of America

Library of Congress Catalog Card Number: 2004105269

For all general information contact Arcadia Publishing at:
Telephone 843-853-2070
Fax 843-853-0044
E-mail sales@arcadiapublishing.com
For customer service and orders:
Toll-Free 1-888-313-2665

Visit us on the Internet at www.arcadiapublishing.com

Dedicated to past, present, and future Auburn football players, coaches, staff, and fans.

In memory of Paul E. Martin and Brooks Webb Carlisle.

CHARGE! During football's early years on campus, Auburn students often created drawings depicting football scenes to honor the Tigers. Favorite images, such as this illustration from the 1920 *Glomerata*, the university yearbook, show Auburn players determinedly carrying the ball forward despite opponents' efforts to stop them.

CONTENTS

FANS. Auburn coeds have been enthusiastic fans of Auburn's football teams since the first game was played in 1892. Early yearbooks feature sketches of female students sitting in the stands cheering for the Tigers. Drawings, such as this one from the 1903 *Glomerata*, occasionally pictured coeds dressed like players and holding footballs.

ACKNOWLEDGMENTS

With gratitude to my parents, Dr. Robert and Carolyn Schafer; my grandmother, Eunice Henn; Sean Fitzgerald Allen; Carl and Jesse Summers and the Lee County Historical Society Museum; Louise and Alvin Holcomb; Liston and Nancy Eddins and their sons Blake, Brett, and Bart; Chris Danner; the late George Alfonso Wright; John Oliver of Cameragraphics; Connie Moon; Henry Stern; Dorothea Rodriguez-Kabana; Nancy Moran; John Moore; Ian Goodall; the Auburn Athletic Department; the Ralph B. Draughon Library, especially Archives and Special Collections and staff, including Dr. Dwayne Cox, Dr. Lynn Williams, Joyce Hicks, John Varner, Dieter Ullrich, Brenda Prather, Paul Martin, David Rosenblatt, Bev Powers, Alfrieda Brummit, Peter Branum, Michael P. Morris, Marty Olliff, Debbie Fletcher Etheridge, and Andrew Adams. I am grateful to Annie White Mell for saving news clippings and souvenirs from early games; George Petrie, Jack Meagher, Shug and Evelyn Jordan, David Housel, Jeff Beard, Dan T. Jones, the Denson family, Leroy S. Boyd, Carlos Henriquez, Bill Van Dyke, Henry Howell Smith, Frank Haggard, John Thomas, John B. Shirey, Lemuel B. Standifer, and Dana Gatchell for preserving archival material related to Auburn football's heritage; and everyone who has made and/or chronicled Auburn's football history. Because Auburn's football teams have accomplished so much since 1891, it would require thousands of pages and images to document the sport's entire history on the Plains. I have selected mostly illustrations that represent and celebrate the Auburn football tradition and have rarely been seen. Images feature people and events both well-known and obscure. Every fan has his or her favorite Auburn football memories and traditions. I grew up with Auburn football. As a child, I attended Auburn football–themed birthday parties and held an umbrella over my mother and me as I watched Pat Sullivan outrun opponents in the rain and mud to score touchdowns. I remember a fifth grade classmate proudly showing us the black eye he got when he excitedly darted onto the field seconds before the game ended. Because his run-in with Auburn's team happened on the Saturday before school pictures, his prized wound was preserved on film forever. When I was in college, I sat near Bo Jackson in a history class and watched him and the other Southeastern Conference (SEC) Champion players win for Auburn. I hope this book will help readers discover how generations of the Auburn football family has experienced and enhanced the Auburn spirit and celebrate Auburn's gridiron heritage. War Eagle!

FOREWORD

Doctors, lawyers, teachers, farmers, astronauts, military leaders, CEOs, ministers, scientists, salesmen, and parents, generation after generation of the Auburn faithful have grown up to fill the ranks of a multitude of career fields. As young children, few, if any, of these future Aubs had the slightest inkling where their life's work may lead them; however, almost every one of these youthful Aubs shared a common dream—a dream to one day wear the orange and blue of the Auburn Tigers. Just as the flowers bloom every spring, every fall a new group of energetic Aubs fashion their favorite jerseys. The numbers change, but the dream remains the same. I am one of the lucky kids whose dream came true, and I now have the added pleasure of watching my son fulfill his dream of also playing for the Auburn Tigers. No matter how great the wins nor how bad the losses, I live by those final seven words in our beloved Auburn Creed— "I BELIEVE IN AUBURN AND LOVE IT."

—Liston Eddins, co-captain of the 1975 team

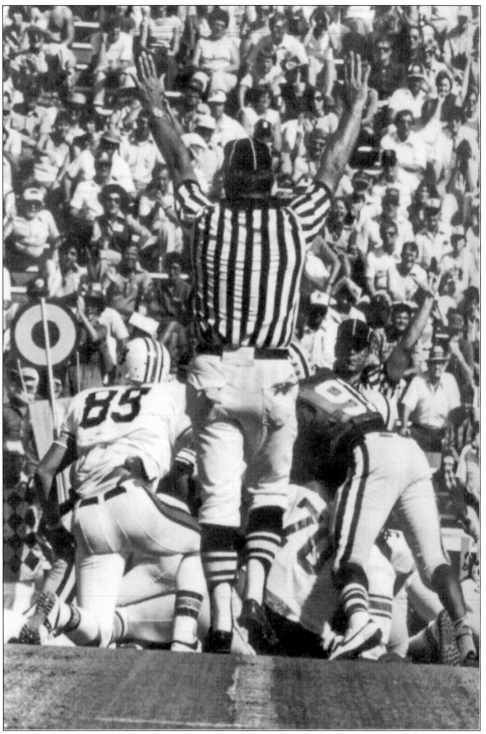

WAR EAGLE! Throughout Auburn's football history, everyone playing, coaching, and rooting for the Tigers is ecstatic when a referee extends his arms high to acknowledge that an Auburn player has scored a touchdown or successfully kicked a field goal.

ONE

Establishing Traditions

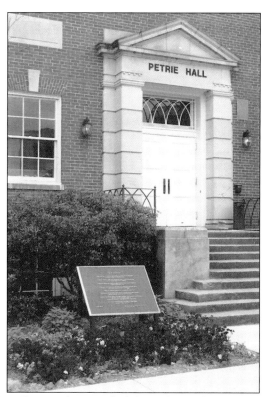

I BELIEVE. Auburn's Beta Omega chapter of Alpha Delta Pi donated this plaque, inscribed with "The Auburn Creed" and displayed outside Petrie Hall. This building, constructed in 1939, is named for Auburn's first football coach, Prof. George Petrie, who wrote the creed. It served as Auburn's Field House for many years because of its proximity to the football field. After the stadium expanded and Beard-Eaves Memorial Coliseum, which included more athletic facilities, was built, Petrie Hall housed several academic departments.

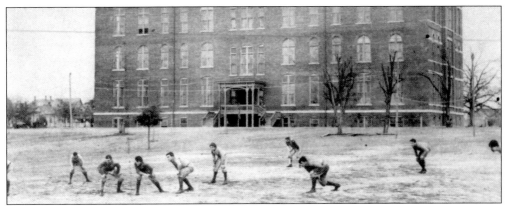

BEGINNINGS. Auburn's first athletic field was behind Samford Hall. Auburn native George Alfonso Wright (Class of 1919) described the field as being half "bare clay which was literally as hard as a rock" and half a "scattering of grass and weeds growing through the sand which had washed down from the side of the rise where Samford Hall stands." He reminisced, "In an East-West direction on this plot a football field was laid out, and in those days it was 110 yards in length with goal posts located on the goal lines. On the slope along Thach Street, some 2"x12" planks were fastened onto suitable supports [for seats]. Most of the spectators, however, stood along the sidelines of the playing field, and crowded near the section where the action was taking place. Town kids, like me, had no status among the students, so the only way we could see what was going on was to watch between the legs of some student."

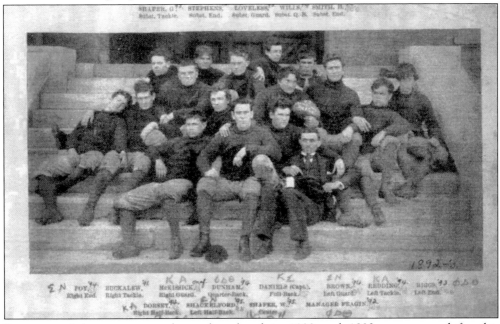

PIONEERS. Auburn team members who played in 1892 and 1893 games posed for this photograph that was published in the *Glomerata*. Handwritten notations indicate the players' fraternity affiliations. Football was one of Auburn's first organized sports. Inspired by rugby games on campus, formal football first emerged in 1891 when Prof. George Petrie formed a varsity team. He recruited the largest men on campus, both students and professors, to establish enduring football traditions on the Plains. Thousands of players since have contributed to Auburn's pioneering football achievements and shaped Auburn's football history.

FOOT BALL,

February 15th, 1896.

BADGE. Annie White Mell, wife of geology professor Patrick Hues Mell, saved football souvenirs, such as this spirit badge that she wore to show her support for Auburn. These badges were typical of the time and the forerunner of modern spirit buttons. She also kept news clippings covering all early Auburn football games. Her scrapbooks are a treasure trove for anyone interested in early Auburn football history.

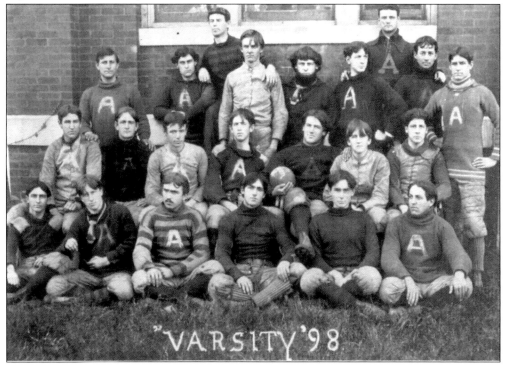

"VARSITY '98

HEISMAN. Auburn's 1898 team is pictured with the innovative Coach John Heisman (wearing a striped shirt in the back row). Heisman tried unique plays "several years ahead of the game as played by other colleges." Player Billy Williams stated, "The first hidden football trick was the child of Coach Heisman's brain." Fond of Shakespeare and drama, Heisman sometimes mimicked a British accent when coaching his players. The 1897 *Glomerata* declared, "[Heisman] came to us in the fall of '95, and the day on which he arrived at Auburn can well be marked as the luckiest in the history of athletics at the Alabama Polytechnic Institute."

To the Team

BY W. R. TICHENOR

THE football season's over
 And suits are laid aside.
 Games won are now historic;
Games lost, less magnified.
Then let us now consider
 The men of that great throng,
Who throughout naught nine's season
 Made Auburn's squad so strong.

There's Reynolds, our captain—God bless
 him—
 And Cogdell, Bonner and Hill
And Beaver, Banks and Noble,
 And Harmon, oft called Bill;
There's Harris, Streit, Dan Herren
 And Davis, our captain next fall,
And Penton, Allen and Locke,
 The gamest old man of them all.

There's Hardage, who played 'gainst S'wan
 And then there's Manager Lind,
And Esslinger, whose bad ankle
 Got broke in each game he was in.
There's Caton, Newall, Powell,
 G. Davis and maybe some more,
Yes, McCoy, whose "Charley horses"
 E'er kept him stiff and sore.

These are the fellows who fought
 'Gainst Howard, Mercer and Tech,
'Gainst Georgia and Vanderbilt
 And 'most made Sewanee a wreck.
Some will no more be with us,
 They've finished their course and away;
Our thanks and our best wishes
 Go with them as well as an "A."

TRIBUTE. W. Reynolds Tichenor, 1896 team captain, wrote this poem to praise the 1909 Tigers. Tichenor had initiated the hidden ball trick at the 1895 Vanderbilt game. W.M. "Billy" Williams recalled, "I was playing left half for Auburn, and Tichenor was quarterback. We were on Vandy's 15-yard line and had the ball in our possession. Tich passed the ball to me; I raised his jersey and hid the ball under it, at the same time dashing toward our right end, protected by several members of the Auburn team." Williams continued, "Vandy thought I had the ball. Tich journeyed around his own left and went over the Vanderbilt's goal line. The first time the Vandy players knew Tich had the ball and had made a touchdown was when they saw him pulling the ball from under his jersey." Football officials later outlawed hiding footballs in play.

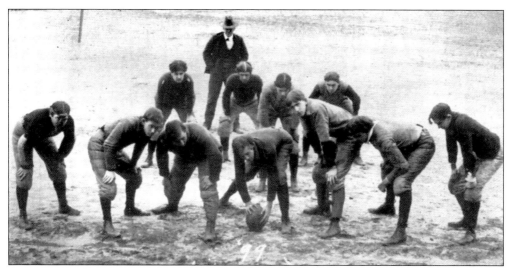

UNIFORMS. This 1899 team lineup shows how the late 19th-century Tigers were outfitted. Writing in the 1960s, George Alfonso Wright reminisced about Auburn's early teams: "The players wore thin canvas uniforms," and "small rugby caps were worn on the field, but were discarded when the game began." Wright explained, "Players were padded much heavier than they are today, and they had to be protected when they hit the ground on that clay field. Shin guards made of crossvine sewn in canvas were used; and nose guards made from a slab of rubber with a bit to clamp between the teeth." Petrie supposedly chose Auburn's colors, orange and blue, to honor his alma mater, the University of Virginia.

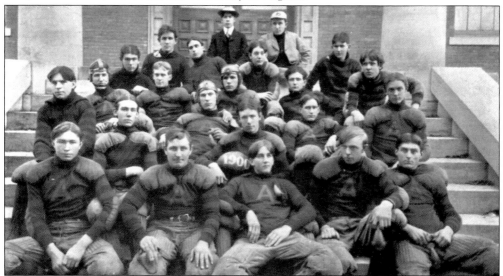

WINNING STREAK. The 1900 varsity squad casually poses for this shot on campus. They were the first Auburn squad to win all of the season's games. The team defeated Nashville 28-0, Tennessee 23-0, Alabama 53-5, and Georgia 44-0. Coach Billy Watkins guided the team to its perfect season the first year after John Heisman stopped coaching at Auburn. Dan S. Martin served as this team's captain. This photograph reveals how football uniforms have changed during the past century, from casual cotton clothing to more standardized garments constructed with synthetic materials. Colleges considered their football team representatives to advertise the merits of their schools. The Auburn Tigers attracted many new students to the Plains.

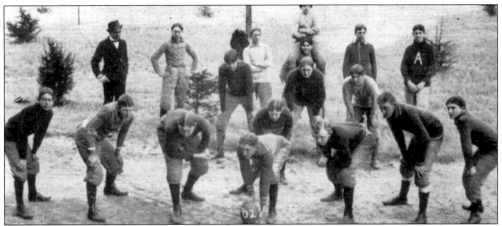

GAME RULES. Football regulations gradually developed as game situations resulted in officials establishing standardized rules and procedures with which teams were required to comply. This 1902 team would have played a game quite different than what modern fans expect. "The methods of playing differed greatly from the football game of today," Wright recalled. "Playing periods were divided into two parts of 40 minutes each and were called innings. Touchdowns counted only four points and a goal counted two points." Awards, titles, and post-season tournaments also were established as the sport developed. James Elmer, a member of this team, was Auburn's first All-Southern player.

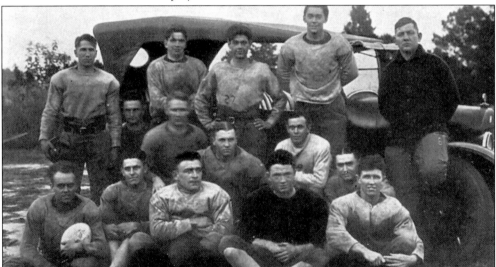

SCRUBS. Auburn's coaching staff relied on scrubs, such as this 1923 group, to condition and prepare the varsity for games. "Hard work, hard falls, and a steady grind best characterizes [sic] the life of a scrub," the *Glomerata* noted. "Very little credit is ever given to the scrub team but the truth of the matter is that the scrubs put the fighting edge on the varsity teams." Coaches taught scrubs the rivals' plays so they could practice those moves with the varsity in scrimmages. "In the old days of mass plays this was not necessary as now, but at present when football has turned to fast, deceptive plays, a team must practice against the opponents' style of play so as to be ready to use the proper defense." Carl G. Gaum (Class of 1908) wrote, "I was Assistant Coach, in charge of the 'scrubs,' unsung heroes who, each year, did so much to make Varsity the good team it was." The "A" Club presented silver As to scrubs, and the coaches gave each scrub a small gold football when teams won championships.

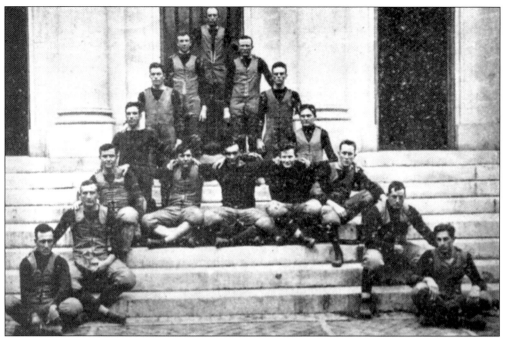

CAMARADERIE. Friends on and off the field, members of the 1911 team link arms to form an A for the official team photograph. This team played successfully at home. They had lost only two games when they made the long train trip to play Texas A&M and the University of Texas in Dallas and Austin. George Alfonso Wright notes the players are wearing "the straight-jacket style football uniforms of that day—all-in-one pants and vest combination which was laced like a shoe from crotch to throat."

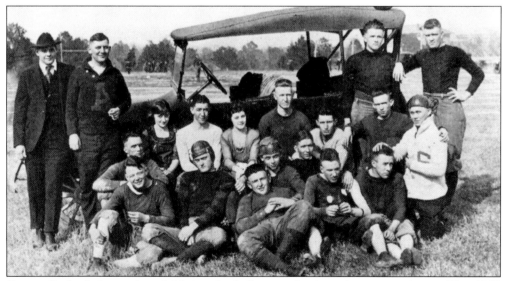

CLASS. Each Auburn class fielded a football team for interclass competitions. The 1919 freshmen class football team, coaches, and sponsors proudly pose with an automobile next to the practice field. The 1924 *Glomerata* explained, "Class football in Auburn is regarded as one of the best methods of obtaining new material for the Varsity. It is one of the many cogs in the great machine that goes to build a Tiger Varsity that will bow its head to none."

H. W. ROBINSON
Captain and right end
Auburn.

OFFICIAL PROGRAM

FOR THE

AUBURN-VANDERBILT

FOOTBALL

GAME

AMMIE SIKES
Captain and left half
Vanderbilt.

Nov. 14 ⚽ 1914

RICKWOOD PARK

BIRMINGHAM, ALABAMA

PROGRAMS. Early Auburn football programs are scarce because they were made of paper materials that easily disintegrated. Archives and museums preserve examples of fragile Auburn football artifacts such as this official program from the November 14, 1914 Auburn-Vanderbilt game. Playing at Birmingham's Rickwood Park, Auburn was victorious 6-0. The program includes "songs and yells" for each team, squad information, photographs of captains, and scores of the rivalry beginning in 1893.

The Swan Song

(On the passing of the old "Gym.")

My day is done, my fate is sealed,
　　Alack, the die is cast!
For Modern Progress bids me join
　　The phantoms of the past.

And now I must be taken down
　　And parted limb from limb,
Will no one shed a tear, or sigh,
　　"Farewell, thou dear old Gym?"

I am not comely—that I know
　　But faithful aye, and true,
And many heroes have I trained
　　To fight for Orange-Blue.

I'm alma mater to a host
　　Invincible afield;
In merit shown by work well done
　　To no upstar I yield.

Is there just meed for service done?
　　Then chant a parting hymn
And croon with feeling this refrain:
　　"Goodbye, old faithful Gym."

　　　　　　　　—R. W. BURTON.

GYMNASIUMS. Auburn's first gymnasium was located in the attic of Old Main (replaced by Samford Hall after a fire). By 1896, a wooden gymnasium was built adjacent to the first athletic field on the current site of Foy Union. The football team's dressing room was in the basement. George Alfonso Wright stated, "From the dressing-room of that gym emerged some of the greatest and toughest football players of the time." In the early 1910s, Auburn graduates and supporters raised funds to build the Alumni Gymnasium. The 1916 *Glomerata* printed local writer Robert W. Burton's ode to the wooden gymnasium.

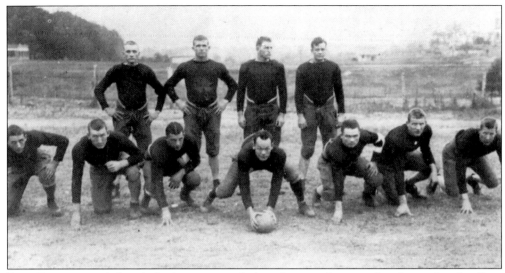

RAT FOOTBALL. Auburn's freshmen team helps players adjust to the demands of college football. Also known as the "Baby Tigers" and "Auburn Cubs," Auburn's rat team, such as this 1926 squad, trained and played other schools' rat teams in preparation for joining the varsity. During summer 1925, the first freshman coach and former Auburn player, "Red" Brown, "combed the South in an effort to bring promising material for future teams . . . the Freshies began their practices and some 120 aspirants answered the call to action." When James Ralph "Shug" Jordan Jr. (his nickname is pronounced like "sugar" becasue he liked to eat sugar cane and his surname is pronounced "jur-dan") was the freshman coach in the early 1930s, his "lengthy weeding out process involving daily scrimmages against the varsity and among themselves, produced the most successful plebe gridiron aggregation in the history of Auburn." His undefeated freshman players included future All-American Jimmy Hitchcock. Auburn also allows qualified players to walk on; many walk-ons have later been offered scholarships and become notable players.

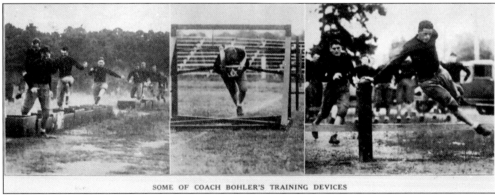

SOME OF COACH BOHLER'S TRAINING DEVICES

PRACTICE. Auburn coaches insist players practice diligently. Coach George Bohler used this training equipment in the late 1920s. Players practiced on Drake Field, the site of modern Haley Center parking lots. The *Glomerata* reported, "There are always a flock of Auburn men out to see the practice sessions as well as the townspeople and merchants who sometimes lock up their places of business and sojourn to the field for an afternoon to be spent in watching the Plainsmen practice." The students hoped practices would "bring back to Auburn the old football glory that she once possessed." Win or lose, Auburn fans could proudly say, "Every man on the team fought hard and clean throughout the season."

STADIUM. Auburn's football stadium was built in a former goat pasture. A creek ran between two hillsides. When the veterinary school's laboratories were located in nearby buildings on West Thach Avenue, the pasture was used to house livestock for hog cholera experiments and other projects. In the mid-1930s, crews diverted the creek from the field's center and covered the area with several tons of dirt and poured concrete on the hills to build stands. The field was originally named Auburn Stadium when it opened in 1939 with 7,500 seats. During the following decades, construction gradually enlarged the stands to accommodate larger crowds.

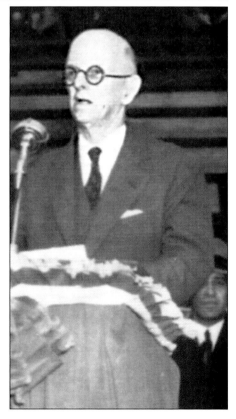

DEDICATION. The first football coach, Prof. George Petrie, speaks at Auburn Stadium's November 30, 1939 dedication ceremony. In 1932, Auburn alumni presented Petrie a plaque commemorating his pioneering role in Auburn football. Known as "The Father of Football at Auburn," Petrie was honored for his sincere love of sports and leadership and his commitment to establishing football as an intercollegiate sport in the South. Petrie's home at 109 West Thach Avenue was across the street from Samford Hall and Auburn's first football field.

FIRST ANNUAL
ELKS FOOTBALL CLASSIC

AUBURN of ALABAMA
VS.
SANTA CLARA

SPONSORED BY B. P. O. E.
No. 3 AND No. 522 FOR
CHRISTMAS BASKET FUND

Price 25 Cents

SATURDAY, OCT. 31, 1936. 2 P. M.

ON THE ROAD. On Halloween, October 31, 1936, Auburn's team played Santa Clara in California in the First Annual Elks Football Classic to raise money for the Christmas Basket Fund. This official souvenir program praised the "conquering legion of Plainsman." A local newspaper reported that "Old Auburn men" traveled from "as far" as San Diego and Portland, Oregon, to watch Auburn's first Pacific coast game. Former Auburn cheerleader Neal Johnson taught the crowd Auburn cheers, and fans handed out orange and blue hats. Coach Jack Meagher (pronounced "mar") and players, including Billy Hitchcock, Walter Gilbert, and Joel Eaves, fought hard, but lost 0-12. Auburn alumnus and Chief California Highway Engineer Col. Jack Skeggs arranged for the team to become the first group to cross the newly constructed San Francisco-Oakland Bay Bridge.

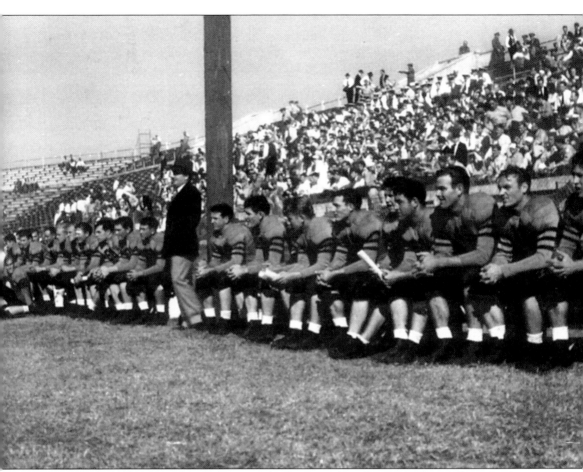

MARAUDERS. This 1942 team was one of the first squads to be pictured in Auburn Stadium. Coach Jack Meagher's players were known as "Meagher's Marauders" because of their aggression on the field—both football and battle fields. This squad was Meagher's last team on the Plains; he enlisted in the Marines during World War II. The team was also Auburn's last until 1944; so many of the players enlisted for military service that no games were scheduled in 1943.

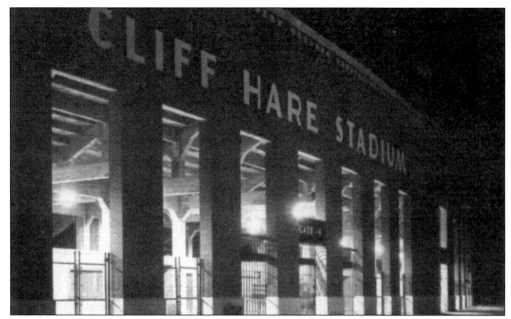

NAMESAKE. In 1949, the stadium was renamed for Cliff Hare, a member of Auburn's first football team and a chemistry professor. Hare loved sports and emphasized, "Athletics makes men strong; study makes men wise; character makes men great." A reporter wrote that Hare "and his pipe are on the sideline whenever an Auburn eleven goes into action. Through fair weather and foul he sticks by the team and in the darkest days of Auburn's competition, he has looked ahead to see a rosy future." The reporter noted, "Despite his keenness for the game, he barely betrays emotion, but he never misses a play."

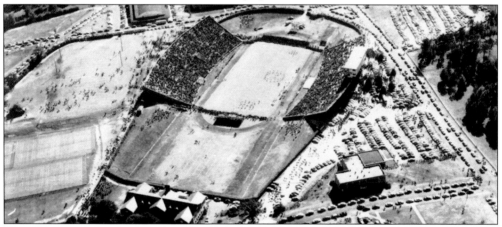

GROWTH. This aerial 1955 photograph shows the stadium's horseshoe shape before it was enclosed at the ends. George Alfonso Wright wrote that because "Auburn was a small town and its facilities were not conducive to scheduling at-home games with the stronger teams in any branch of athletics," football games were often played at other locations. Auburn's teams traveled by train throughout the South and to such distant venues as New York (to play Army at West Point) and Michigan (to defeat Detroit University). Auburn administrators approved continued expansion to help Auburn gain a home advantage. The field was completely enclosed by 1970. Auburn's stadium dramatically grew from several bleachers in a pastoral setting to an elaborate structure that dominates the 21st-century landscape.

LETTERMEN. Auburn Tigers aspired to earn a letter to indicate their contribution to Auburn's varsity football teams. This image in the 1919 *Glomerata* celebrates the varsity players' athletic accomplishments. The Auburn Football Lettermen Club (http://www.auflc.org), composed of alumni players, raises funds for scholarships and sponsors activities such as races on A-Day.

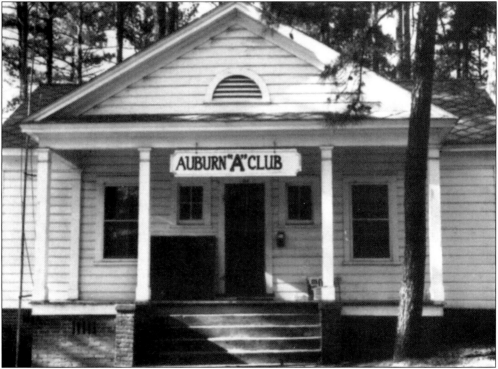

"A" CLUB. Members of the "A" Club, consisting of lettermen in Auburn's major varsity sports, managers, and three-year cheerleaders, enjoyed this clubhouse in Graves Center. These cottages were built during the Depression. Football lettermen relaxed by using the cottage's recreational facilities. They liked having a central meeting place to discuss game strategies and ambitions with teammates. Before Sewell Hall was built to house male athletes, players lived and ate in local boarding houses. The "A" Club raised money to buy a public address system and other equipment athletics personnel need. New members undergo initiations that often amuse classmates and townspeople.

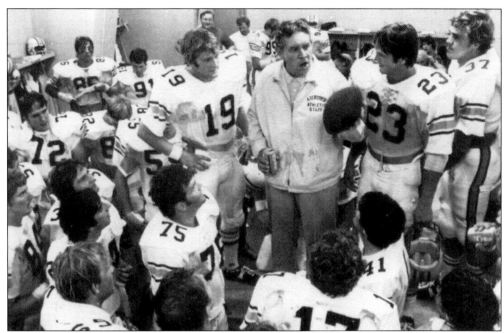

TEAMWORK. Coach Jordan talks with his players in the locker room during the 1972 10-1-0 season. He was named SEC Coach of the Year for that season's accomplishments. Many of his players described Jordan as a fair and inspiring mentor interested in their athletic and academic development who helped them pursue and attain career aspirations, whether in sports or other professions. Jordan capably encouraged the camaraderie and sportsmanship that helped his players recognize individuals' strengths and perform well together during games. The Shug Jordan Award is given annually to an outstanding senior football player.

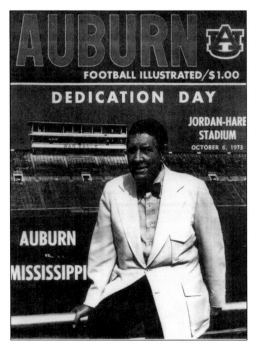

JORDAN-HARE. Coach Jordan was Auburn's most revered and beloved football coach. This game program commemorates the addition of Jordan's surname to rename Auburn's stadium, the Jordan-Hare Stadium, in his honor. Shug Jordan Parkway, which encircles Auburn, also memorializes Auburn's most outstanding coach. Jordan was the first head coach for whom a namesake stadium was declared while the coach was still coaching. The stadium constantly undergoes expansion to seat more fans (86,063 total since the 2001 construction) and includes luxury skyboxes and murals depicting football traditions. Jordan-Hare is one of the largest U.S. college football stadiums. Auburn's Yardage Program encourages fans to name a square yard for a fee according to the location on the field and if an outstanding play occurred there. Fans can invest in the field by contacting Tigers Unlimited (http://www. TigersUnlimited.com and 1-800-AUB-1957).

TWO

Notable People

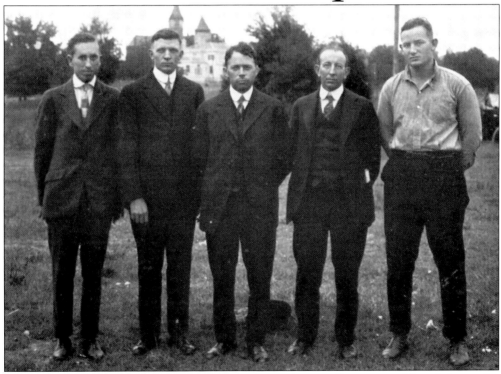

LEADERSHIP. The following members of the 1919 coaching staff are pictured from left to right: graduate manager Jonathan Bell Lovelace, student manager T.B. Howle, head coach Mike Donahue, and assistant coaches R. Ticknor and William C. Louiselle. After earning two Auburn degrees, Lovelace became a successful investment entrepreneur. To honor Lovelace, his family and friends provided Auburn with funds to establish the Lovelace Museum and Hall of Honor (http://www.lovelacemuseum.com) located at Auburn's Athletic Center. The museum preserves artifacts from all Auburn sports and provides fans interactive displays to experience and celebrate Auburn football's spirit, traditions, and history.

JORDAN. This 1930 *Glomerata* photograph shows Shug Jordan, known as "Lefty" to his teammates, when he played center on Alabama Polytechnic Institute's squad. The *Glomerata* declared, "He was as accurate a passer as could be found in many a day's search, and his defense work was good." Shug also was a valuable player for Auburn's championship basketball and baseball teams. His peers voted him the Most Outstanding Athlete at Auburn. After graduation, he was an assistant football and basketball coach at Auburn, mentoring the freshman squad. With the Army Corps of Engineers during World War II, Jordan fought in Europe, North Africa, and Asia and received a Purple Heart for injuries sustained during the D-Day invasion. He became Auburn's head football coach in 1951. By the time he retired in 1975, his Auburn teams had won 176 games. Jordan was named National and four-time SEC Coach of the Year.

HARE. Clifford "Cliff" Leroy Hare played substitute quarterback on Auburn's first football team. A native of Lee County, Hare was familiar with Auburn as a child. He earned a bachelor's degree in chemistry in 1891 and a master's degree the next year. During his professional career at Auburn, he taught chemistry courses, was the state chemist, and served as dean of the School of Chemistry. Hare was the head of Auburn's faculty athletic committee and helped establish Auburn's first golf course. His peers elected him president of the Southern Conference, and newspapers declared "New S.C. Leader Auburn Favorite—'Cliff' Hare Long an Ardent Rooter and Keen Student of Game." In addition to the stadium bearing Hare's name, Auburn annually presents the Cliff Hare Award to a superb varsity athlete.

ROUGHING IT. H.S. Kent, pictured at right, was Auburn's head coach, with Mike Harvey, in 1902. Kent's players joined the team because of their love for football and competition; no scholarships were offered. Blois Hill, who played on Kent's 1902 team, had not seen a football until he came to Auburn. Watching players engaged in a "rough" game, he decided to sign up for the team. Each player had to supply his own shoes and helmet. Fall practice began when school started, not during the summer like modern teams. Blois said passing was not routine, and players "went straight ahead and ran." Kent had to endure when opponents took advantage of the lack of rules. In 1902, "When Auburn had the ball, three or four Tulane players would be found on the ground after every play begging for a two minute delay." Their strategy to force a stalemate worked and the tied game was stopped when it became too dark to play, preventing Auburn from winning.

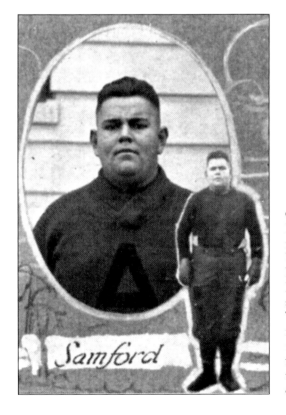

COMMUNITY. Varsity football guard James Drake Samford (Class of 1920) not only made an impact on Auburn's college team but also on the city's athletics. Better known as "Duck" Samford, the Montgomery native majored in agriculture and played both class and varsity football. The yearbook praised, "Whenever he received his chance he put his whole effort into the game." The Auburn High School football stadium and the surrounding fields for Little League and other sporting competitions are named for Duck Samford.

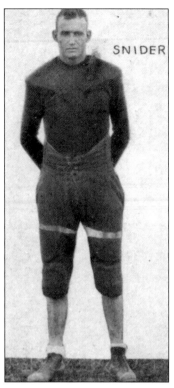

SNIDER

OLYMPIANS. Some Auburn football players have also competed in the Olympics. The *Glomerata* noted halfback Snitz Snider was "one of the fastest men in the conference." He competed in track events at the 1928 Olympics in Amsterdam. Returning for the fall football season, Snider, "fresh from his trip to the Olympic games as a member of the United States team, had the misfortune to hurt his ankle early in the season with a bad wrench from which he never full recovered." Auburn's 1927 track captain, W.O. "Weemie" Baskin, also played varsity football and participated in Olympic track events. Baskin served as an assistant football coach in 1930.

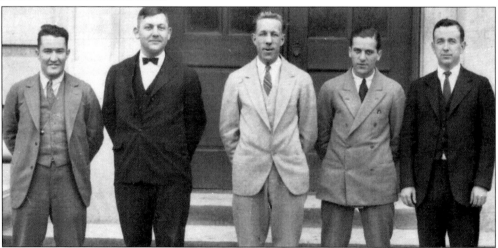

MENTORS. Auburn's football team benefited from a compatible group of coaches. In this 1925 photograph, freshman coach "Red" Brown stands to the left. John E. "Boozer" Pitts, second from left, had played on the Tigers' 1913 and 1914 Southern Championship teams and was the "greatest center that ever wore an Auburn uniform." Admired for his "determination and fighting spirit," Pitts was Auburn's head coach in 1923 and 1924, returning as line and scrubs coach for the 1925 season and then as head coach again in 1927. The yearbook stated, "He was one of the youngest coaches in the country, but one of the best." Head coach and athletics director David Morey stands next to him. Assistant coach Mike Papke stands next to Wilbur Hutsell, Auburn's head track coach, who is on the far right. During his career, Hutsell provided his skills as trainer and athletic director to improve the football squad.

HOPE. Appropriately named head coach Chet Wynne gave Auburn fans football victories and action to cheer them up during the Depression. His teams managed to travel to games despite the economic uncertainties of the time. Coaching from 1930 to 1933, Wynne guided his teams to two winning seasons, including the Southern Conference Championship in 1932, when Auburn had nine victories and one tied game. Wynne coached such notable Tigers as 1932 captain Jimmy Hitchcock and talented All-Southern end David "Gump" Arial. The Plainsmen had not enjoyed an undefeated season since 1914.

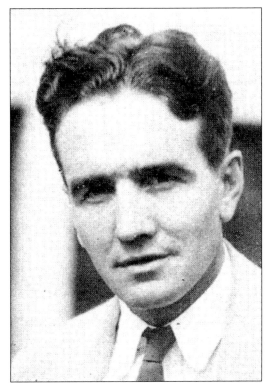

CO-CAPTAINS. After Tom Daniels and R.T. Dorsey served as the 1893 team's co-captains, all Auburn squads had only one captain until 1931 when M.V. "Chattie" Davidson, left, and J.D. Bush, right, were designated co-captains. The 1944 and 1946 teams had co-captains, but the dual title did not become a standard tradition at Auburn until the 1960s.

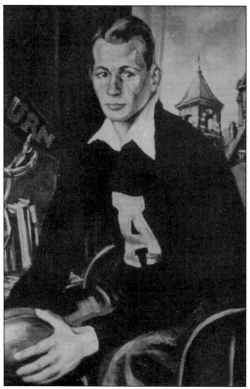

ALL-AMERICAN. Jimmy Hitchcock, Auburn's first football All-American, was honored at the 1933 Tournament of Roses with other All-Americans. Teammates admired Hitchcock for his "clean sportsmanship and inspiring leadership." According to the *Glomerata*, "Hitchcock's blocking, passing, punting, and tackling made him a nuisance to everyone wearing the colors of his opponents. Many Plainsman followers were thrilled time and again as Jimmie cat-walked, pivoted, and side-stepped his way along the sidelines of the field for lengthy gains." He made 232 punts with none being blocked. In the off-season, Hitchcock played baseball. Auburn's Hitchcock Field at Plainsman Park was named for him and his brother Billy, who also lettered in football at Auburn, then played for the New York Yankees and was a professional manager and scout. Jimmy Hitchcock was elected to the Alabama Public Service Commission and inducted into the National Football Hall of Fame. Sidney William Jirousek Van Sheck painted this portrait of Hitchcock.

INSPIRATION. Coach Jack Meagher came to Auburn from Notre Dame, where he was influenced by the legendary Knute Rockne. Meagher had a 48-37-10 record during the seasons he coached the Tigers (1934 to 1942). Walter Gilbert (Class of 1936) was one of Meagher's most outstanding players. Sportswriter Bill Blake lauded Gilbert's endurance in a game against Louisiana State University (LSU) where he "took a terrific pounding, but he never stopped charging through to nail the ball-carrier." Blake declared, "There is none who can equal the Auburn center." Gilbert was Auburn's second All-American and was also named to the College Football Hall of Fame. The Walter Gilbert Award honors varsity athlete alumni who have achieved a minimum of 20 years of outstanding professional success. When the Tigers decided to serve their country in World War II, Meagher set an example by enlisting in the Marines. After his tour of duty was completed, he returned to coaching football with such teams as the Iowa Seahawks.

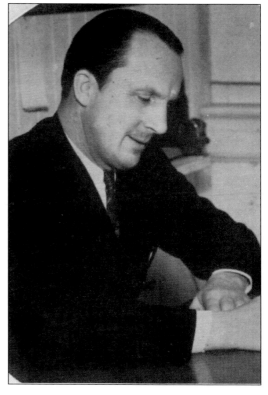

SENATOR. Auburn football players often seek political careers after their years of playing on the Plains. The Tigers can claim alumni serving in local, state, regional, and national offices. William F. "Bill" Nichols (B.S. 1939 and M.S. 1941) attained fame on the field and in the United States Senate. Receiving a football scholarship, he played on Auburn's 1937–1939 teams and used his skills honed on the gridiron to become successful professionally. After graduation, Nichols worked as an assistant farm agent. He fought in World War II and lost a leg; then he became a businessman before winning offices in the Alabama House of Representatives and Senate and in the United States Congress and Senate. During his political career, he supported legislation for the armed services. Auburn's ROTC is housed in the Nichols Building, which is named in his honor.

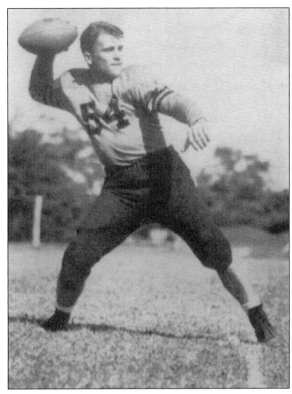

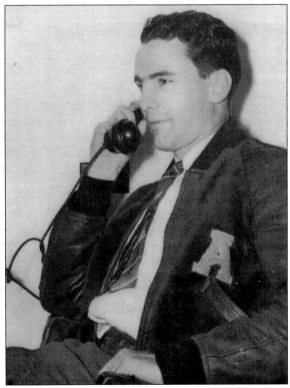

BABE. Coleman H. "Babe" McGehee played Auburn football from 1939 to 1941 and was the "A" Club president in 1940. McGehee scored the fist touchdown in Auburn Stadium. He piloted a heaver bomber for the Air Corps in the Second World War. Returning to Auburn, Babe McGehee established a printing business. Shug Jordan wanted to put a tiger design on football helmets, and publicity director Bill Beckwith wanted an eagle design. Athletic director Jeff Beard suggested putting the AU logo on helmets. When Beard prevailed, McGehee oversaw the application of the logo on Auburn's helmets. His wife, Susan Mizelle "Suzelle" Hare (Class of 1940), was Cliff Hare's daughter. The McGehees were ardent supporters of Auburn football.

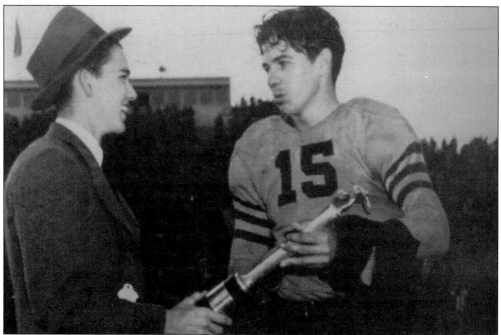

STELLAR. Dick McGowen (Class of 1941) played an important part in Auburn's football history; he threw the first touchdown pass in the new Auburn Stadium when Auburn played its first game there on November 30, 1939, tying Florida 7-7. Playing from 1938 through 1940, he received the Blue Key Outstanding Player Trophy at Homecoming, as pictured here, twice. The *Glomerata* emphasized, "Dick McGowen was Mister Football." When Auburn beat LSU at Baton Rouge 21-7 in 1939, "Ol' Richard the Lion Hearted ran rampant, scoring two touchdowns, booting two more extra points, passing sharply and truly." During his Auburn career, McGowen set records for yardage and punts. He joined Auburn's coaching staff and helped to train the 1957 National Championship team. McGowen was inducted into the Alabama Sports Hall of Fame.

"LEAPIN' WILLIE." W.T. Yearout, better known to fans as "Leapin' Willie," was not afraid to take a dive for the Tigers. He is shown here leaping over Tulane's players to cross the goal line in Auburn's 1940 victory over that team (20-14) in New Orleans. More than four decades later, Bo Jackson would make a similar leap to secure victory for Auburn over Alabama.

LEGACY. The first football coach, Prof. George Petrie, holds a silver-plated trophy that alumni gave him in 1941. The football shaped trophy was inscribed: "For over fifty years he has taught Auburn men to 'carry the ball' not only on the gridiron but in every worthwhile field of human endeavor. Eminent as an educator and loveable as a friend." The trophy is located in the Petrie Collection in the Auburn University Archives and Special Collections. Petrie loved sports; when he wrote the Auburn Creed, he stated, "I believe in a sound mind in a sound body and a spirit that is not afraid, and in clean sports that develop these qualities."

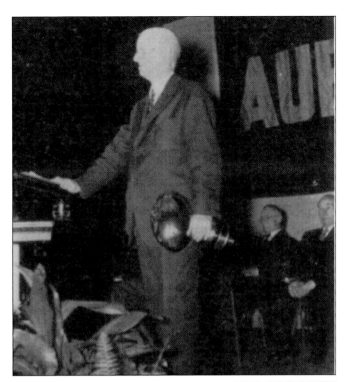

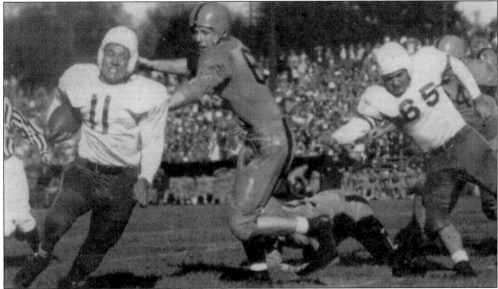

GO, TRAVIS, GO. All-American offensive back Travis Tidwell played from 1946 to 1949. His spectacular playing style was evident in his freshman season when he scored three touchdowns in Auburn's 47-12 defeat of Florida at Gainesville. Sam Adams wrote in the *Alabama Journal*, "Travis Tidwell put on a show that will long be remembered in these parts." Setting records, Tidwell could be counted on to run fast to score. Fans adored him, especially when he helped Auburn beat Alabama 14-13 in 1949. Max Moseley of the *Montgomery Advertiser* praised, "Traveling Travis Tidwell, the SEC's most valuable player, proved his worth. The 185-pound Birmingham boy finished his grid career in a blaze of glory as he led his mates to victory."

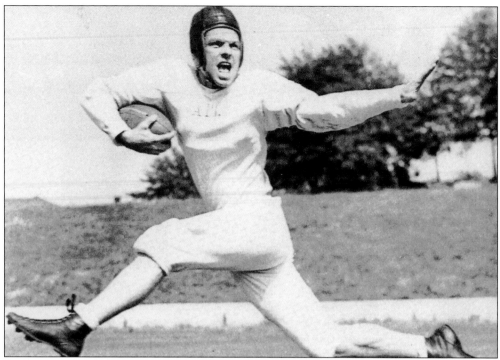

DETERMINED. Curtis Kuykendall played football for Auburn before and after World War II, helping the team regroup after the cancelled 1943 season. In 1944, Kuykendall was the most experienced player on the fledgling team, teaching Coach Carl Voyles and his staff about Auburn football traditions and helping the new players acclimate to the demands of varsity college football. On the field, Kuykendall shone. In the team's first game, a 32-0 victorious match against Howard University, Kuykendall was "starring" for almost the entire game. In the season's final game against Miami University in Miami, "Curtis Kuykendall strengthened his claim as one of the best backs in the South by gaining a total of 228 yards and scoring four touchdowns." Auburn won 38-19.

RATINGS WIZ. Paul Bernard Williamson (Class of 1912) used his Auburn education and love for sports to develop a nationally syndicated, scientific college football rating system that was praised for its high 87 percent accuracy and used by such notable football figures as Walter Camp, whom he had met in Boston. The *Auburn Alumnus* recalled, "While at Auburn, Mr. Williamson was quite a football enthusiast and followed the game closely." Discussing his weekly rating statistics, Williamson wrote, "The least was 325 a week because of and during World War II. This fall [1946] 750 teams have been handled regularly for the 1946 season. We predict on every game we can find out about."

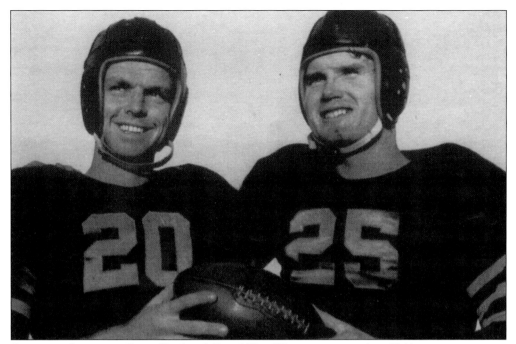

GRIDIRON LEADERS. Curtis Kuykendall and Tex Warrington served as 1944 team co-captains after "a year without football, a year in which that Auburn Spirit waned but did not die, a year in which 'War Eagles' were as scarce as cigarettes." After a 4-4-0 season, center Warrington became Auburn's fourth All-American. Kuykendall, rushing an average 105.1 yards a game, was designated All-Southeastern and a second team All-Southern. He was the sole captain in 1945.

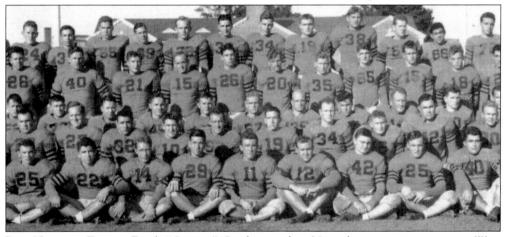

PRO HALL OF FAMER. Frank "Gunner" Gatski, number 38 in this team picture, was a West Virginia coalminer who played at Marshall University then served in World War II. After the war, he played for Auburn during the 1945 season. The next year he signed with the Cleveland Browns as a center and defensive linebacker. He also played for the Detroit Lions. Gatski was named to All-Pro teams and played in 11 championship games. Player Chuck Bednarik described Gatski as "an immovable object" and the "best and toughest I ever played against." Many Auburn players have played for professional teams and in the Super Bowl. As of 2004, Gatski has been the only Auburn player, so far, to be inducted into the Professional Football Hall of Fame.

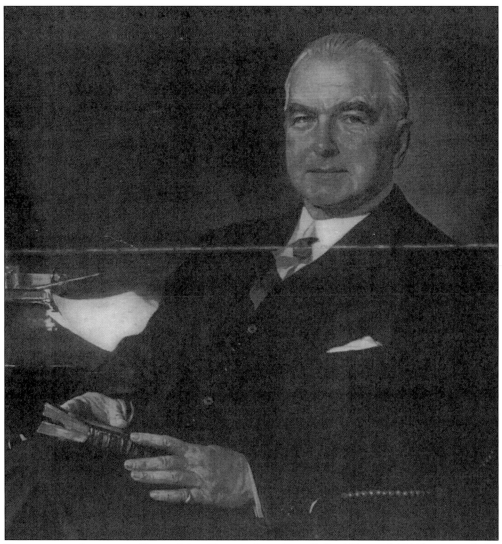

DOWNTOWN ATHLETIC CLUB. John Cunningham Postell Jr. (Class of 1912) received the Hearst Medal "upon his retirement in 1953 as President of the Downtown Athletic Club for recognition of long years of leadership and service rendered toward preservation and improvement of Downtown Manhattan." A chemistry and metallurgy major from Savannah, Georgia, Postell played football for his freshman class. As a lifelong fan of the gridiron, he was selected for membership to the exclusive New York City Downtown Athletic Club, which presented the Heisman Award for many years. Unfortunately, Postell did not get to see Auburn's two Heisman winners.

GOVERNOR. Offensive back Forrest H. "Fob" James Jr. is shown accepting the Blue Key's Most Outstanding Player Trophy in 1955. That same year, he was named an All-American. His football prowess awed fans in the early 1950s. James belonged to a football family in which relatives, including his father Fob Sr. and son Tim, played for the Tigers. James's football reputation aided him in developing the internationally known athletic equipment manufacturer Diversified Products, which was based near Auburn in Opelika. Football also aided his political aspirations. He was elected Alabama governor twice, in 1978 and 1994.

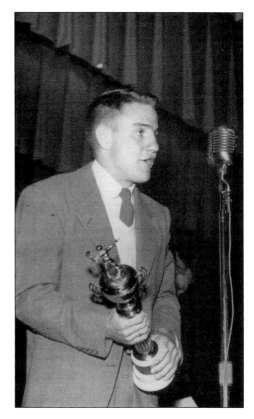

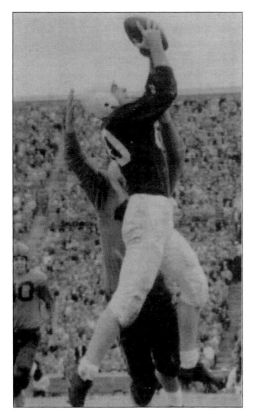

PASS COMPLETED. The Tigers could count on receiver Jim Pyburn to keep the football out of enemy hands and move it down the field to the goal line. He caught this pass to score a touchdown in front of a crowd of 24,000 people during the 1954 Homecoming game against Clemson, which Auburn won 27-6. It was the Tigers' fifth consecutive win in that 8-3-0 season, which included a victory over Bama and a Gator Bowl trophy. Pyburn was named an All-American that year.

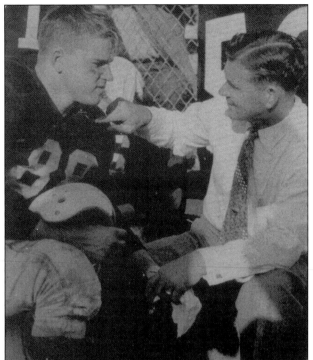

LEGACY. James "Jimmy" Wallace Long, Auburn's 1954 team captain, and his father, H.J. Long, the 1929 Tiger captain, share a moment on the sidelines. The two generations of Long football captains symbolize the importance to many families of establishing a tradition of several generations playing for Auburn. Many sons and grandsons have followed in the cleats of fathers and grandfathers, and future descendants will aspire to continue their family's role in Auburn's football heritage.

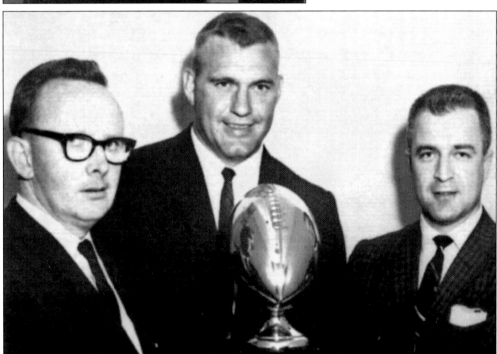

OUTSTANDING. Defensive lineman Zeke Smith, center, accepts the Most Valuable Player trophy from Tiger Theater manager Don Stone, left, and sportscaster Tom Hamlin, right. Smith and center Jackie Burkett received All-American Awards in 1958 and 1959. Smith also was honored with the Outland Award for America's best interior lineman.

EXCELLENCE. Jimmy Sidle was an outstanding Auburn quarterback who set SEC records for rushing and passing. In 1963, he became the first quarterback in the United States to rush the most yards during a season—a total of 1,712 yards, more than any other college player. Sidle was designated an All-American, SEC Player of the Year, and Most Valuable Back that year. He was a favorite for the Heisman Trophy before an injury interrupted his collegiate career. Sidle later played for several professional football teams.

From The Desk of

REV. JAMES L. PHARR, PASTOR
FIRST BAPTIST CHURCH
HIGH POINT, NORTH CAROLINA

March 6, 1964

Dear Bill:
I recently read Drew Pearson's Column entitled "Church Leadership." I read with pride about how you welcomed Franklin to the Campus—
I love Auburn and had the honor of being Captain of the 1946 football team—
Thanks for making me feel proud of my Alma Mater. Cordially
Jim Pharr

CHARACTER. John William "Bill" Van Dyke (Class of 1964) exemplified the characteristics often associated with many Auburn athletes for doing the right thing. Rev. James L. Pharr, Auburn's 1946 team captain, wrote this letter to commend Van Dyke for introducing himself, shaking hands, and welcoming Harold Franklin, Auburn's first African-American student, to campus in January 1964 despite some public resistance to Auburn's integration. Van Dyke, who recalled including childhood black team members "for the 'pasture football game' that all kids love to play," later wrote, "I simply was trying to make this young man feel at home and know that he was in a friendly environment." He noted that they sat together because "if anybody was going to do something to disrupt the class, they were going to have to go through me." Media publicized the students' friendship and Van Dyke weathered both support and disdain.

INTEGRITY. Garland Washington "Jeff" Beard was Auburn's athletic director from 1951 to 1972. His brother Percy Beard was an Auburn athlete and Olympic silver medalist. Jeff Beard's term as athletic director was during the glory days of football on the Plains when Shug Jordan coached, Auburn won a national championship, and Pat Sullivan won the Heisman. Beard oversaw stadium improvements such as the press box addition and increased seating capacity by 40,000. He scheduled Auburn's home games to be played at the stadium instead of host cities, bringing many Tigers' rivals to Auburn for the first time. Sewell Hall athletic dormitory was built. After Beard died, the handball courts were named for him and his name was added to the coliseum's title to become Beard-Eaves Memorial Coliseum.

DEDICATED. Auburn alumnus David Housel (Class of 1969) has performed many jobs for Auburn football. A former *Plainsman* editor, Housel covered sports. He wrote for the *Huntsville News* for a year after graduation and then returned to Auburn to assist the athletic department. His duties have included overseeing the ticket office, editing football programs, and helping in the press box during games. Housel also taught journalism classes and served as *Plainsman* advisor. He was assistant sports information director in 1980, then sports information director from 1981 to 1994 before becoming Auburn's athletic director. Housel wrote *Saturdays to Remember* and *From the Desk of David Housel*.

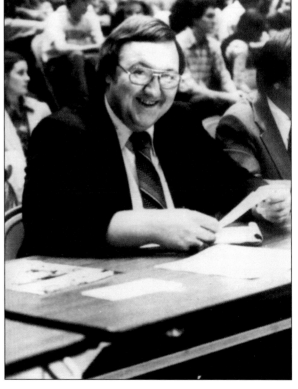

VOICE OF AUBURN. Jim Fyffe announced Auburn football games for 22 seasons. Providing play-by-play commentary for the Auburn Network, Fyffe enthusiastically created slogans that are familiar to Auburn fans. His "Touchdown Auburn," "Bo over the top," and "Bye-Bye Bo" are some of his best-known cries. Fyffe dedicated his memoir, *Touchdown Auburn! Memories and Calls from the Announcer's Booth*, written with Rich Donnell, "To Auburn, which gave me the chance I dreamed of." When Fyffe unexpectedly died in May 2003, the Auburn community mourned him. At the August 30, 2003 season opener against the University of Southern California, the game program was dedicated to Fyffe and a video tribute commemorated him. Auburn's cheerleaders taught fans a new cheer in Fyffe's memory, telling people on the east side of the stadium to yell "Touchdown" and then those on the west side to respond "Auburn!"

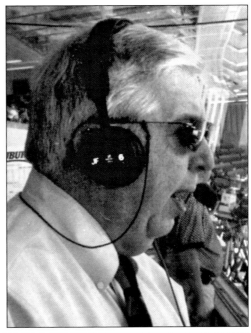

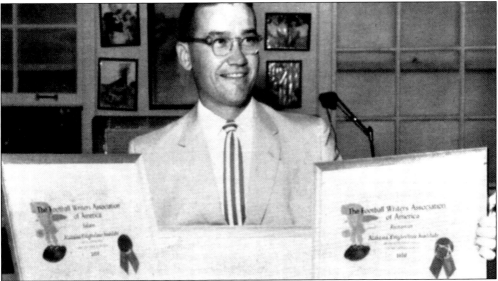

PUBLICITY. Bill Beckwith, director of sports public relations, proudly shows awards from the Football Writers Association of America for articles he prepared about the Tigers. Auburn gave Beckwith and sportswriters wonderful information to report. Fascinating Auburn football personalities included versatile 1964 All-American player Tucker Frederickson, whom Shug Jordan called "the most complete football player I've ever seen." Frederickson's skills generated Heisman buzz, and he was the number one NFL draft pick, playing for the New York Giants. In the press, Frederickson was described as "well-mannered," "totally fearless on a football field," and "a football player's football player." He was inducted into the College Football Hall of Fame. Auburn alumni and NCAA presidents Dr. Albert B. Moore (Class of 1912) and Dr. Wilford S. Bailey (Class of 1942) were also frequently in sports coverage, with Moore declaring, "I learned to love football at Auburn."

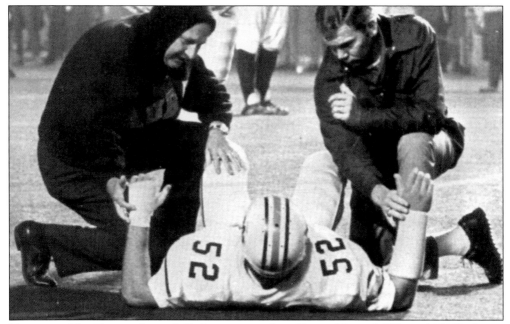

TRAINERS. The Tigers rely on skilled trainers, such as Kenny Howard (Class of 1948), shown here on the left of the downed player, to help them maintain optimum athleticism, physical fitness, and agility. Trainers assist injured players on the field and, with the help of team physicians, monitor rehabilitation. Howard was Auburn's head athletic trainer from 1952 until 1976, when he became assistant athletic director for four years. He also served as an Olympic athletic trainer. The National Athletic Trainer's Association (NATA) Hall of Fame inducted Howard in 1976; he was also on the NATA board of directors. Howard was inducted into the Alabama Athletic Trainers' Association's Hall of Fame in 1995.

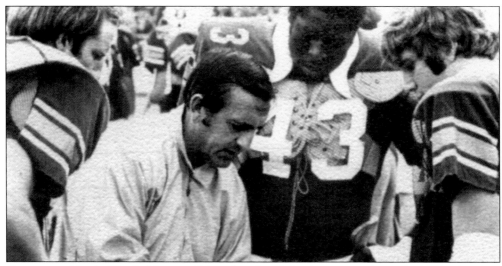

STRATEGY. Coach Claude Vincent Saia, who played for Auburn in the early 1950s, discusses plays with Tigers on the sideline. Saia's book, *A Winning Football Bible*, outlines his philosophy of football and how players and coaches should mentally prepare themselves for games with confident attitudes. His book emphasizes strategies for success on the field, including diagrams of plays that proved successful for teams he coached.

42

SULLIVAN TO BEASLEY. Pat Sullivan and Terry Beasley wowed fans from 1969 to 1971. Sullivan skillfully threw the ball to cover 2,500 yards to Beasley during their Auburn careers. Passing and running for a total of 71 touchdowns (a NCAA record), Sullivan was named the SEC's Most Valuable Player and won the Walter Camp Award and Heisman Trophy in 1971. Beasley was eighth in the Heisman voting that year. Their jerseys were retired after the 1971 season. Souvenirs celebrated the pair, including bumper stickers that read "Super Sully and Terry Terrific." Both played in the NFL and were inducted into the College Football Hall of Fame. Sullivan coached Auburn quarterbacks and is currently head coach at UAB.

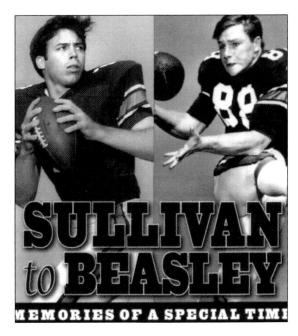

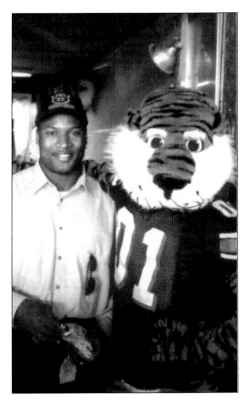

BO KNOWS AUBURN. Bo Jackson and Aubie get reacquainted at an Auburn game. Jackson set Auburn football afire when he arrived on the Plains in 1982. Twice named an All-American, in 1983 and 1985, Bo raced down fields so fast that he was a blur to opponents. He accumulated many Auburn, SEC, and NCAA awards and records, including Most Valuable Player at the 1984 Sugar Bowl and Liberty Bowl. In 1985, Jackson was designated Player of the Year and received the Walter Camp Award. He was also named Outstanding Offensive Player at the 1986 Cotton Bowl. His crowning achievement was winning the Heisman Trophy that year. A versatile athlete, Jackson also ran track and played baseball for Auburn. He was inducted into the College Football Hall of Fame. During his professional athletic career, he played football for the Los Angeles Raiders and baseball for the Kansas City Royals, Chicago White Sox, and California Angels. He appeared in Nike commercials that made him famous worldwide. Jackson's number 34 jersey was retired during Auburn football's centennial festivities at the 1992 Homecoming halftime ceremony.

CATALYST. As Auburn's head football coach and athletic director from 1981 to 1992, Pat Dye got things done. Not only did Dye coach his teams to win a total of 99 games (tying Mike Donahue's record) and four SEC titles in a 12-year period, he also changed the landscape of Auburn football. Jordan-Hare was expanded to seat 85,214 people. Seventy luxury skyboxes were built to accommodate VIPs and fans willing to invest in the privilege of watching games in air-conditioned comfort with many other amenities. He donated $75,000 of A-Day profits to purchase library books and $1 million of athletic revenues to renovate the library, supporting a $5 million library fund drive. He was the muscle that brought Alabama to play at Auburn in 1989 and then alternate home games in the following years. Dye wrote two memoirs, *In the Arena* and *I Believe in Auburn and Love It: A Collection of Auburn Letters and Essays.*

CONFIDENCE. Tommy Tuberville, Auburn's head coach since 1999, has led teams that have attracted media attention about the potential of future Auburn national championships and Heisman Trophy winners. Fans have loyally supported Tuberville even though his teams may not have performed as expected. Tuberville inspires confidence among the Auburn faithful by his steady determination and persistence to make Auburn the best team in the South and in the nation. Upsets, such as Auburn beating favored Alabama at Tuscaloosa in 2002 and at home in 2003, have won the hearts of Auburn fans who optimistically believe Tuberville promises future greatness to Auburn. Players admire Tuberville so much that they usually decide to stay at Auburn to play their senior season even though they could have been professionally drafted as juniors or younger.

THREE

Historic Rivalries

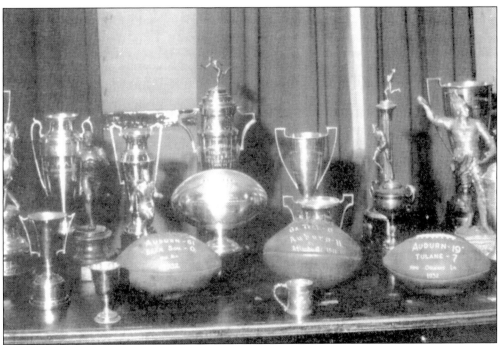

AWARDS. Auburn teams have won numerous trophies, such as these shown in this 1936 photograph, as a result of games with rivals. Many of these rivalries were established within Auburn's first years of organizing a team. Because Auburn's original football field and town facilities were insufficient, many home games against rivals were held in larger cities—Columbus, Birmingham, and Montgomery—with ample hotels and restaurants for fans. Before Auburn expanded Cliff Hare Stadium, rivals often refused to travel to Auburn. When they did finally agree to come, they all lost in their first game at Auburn. Georgia played on the Plains in 1960; Tennessee debuted in 1974; and Alabama showed up in 1989. Beating rivals at their home fields is blissful for Tigers. Auburn stores (Johnston & Malone, Anders, and Tiger Rags) create and sell t-shirts that celebrate Auburn's victories over specific rivals.

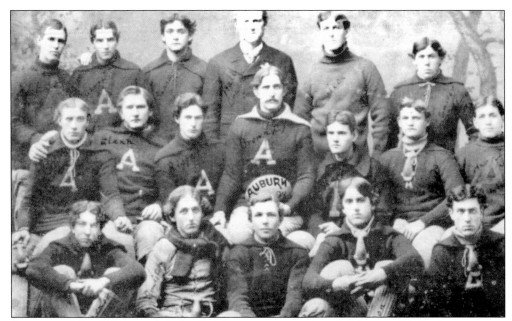

SHUTOUT. The 1894 squad had a lackluster season with a 1-3-0 record. The lone victory, however, was significant. Auburn whipped Georgia Tech 94-0 (the highest score Auburn has ever achieved in its football history.) John Heisman replaced Coach F.M. Hall the next year, securing two wins and a close loss to Vanderbilt. Such an astonishing shutout was not achieved again until the 1899 63-0 defeat of Georgia Tech. When Auburn beat Tech 14-7 in 1919, the *Birmingham News* declared, "Auburn has turned the old town upside down. The gilded youths from the Plains of Auburn celebrated all night and at an early hour this morning were still parading the streets."

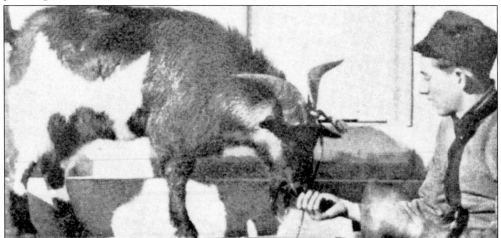

GETTING THEIR GOAT. Abducting rivals' mascots was a favorite activity in the early years of college football. Originally, Auburn mostly had canine mascots, although a goat or two was called to duty, because having a live tiger was impractical and eagles were difficult to find. Kidnapping an opponent's mascot symbolized their vulnerabilities and demoralized fans before games. Auburn students took good care of rival mascots such as this Georgian goat before returning them. School officials discouraged mascot pilfering when mascots such as Georgia's bulldog became valuable animals and, in the case of War Eagle, federally protected.

FLYER. Auburn's first game with the University of Georgia at Atlanta's Piedmont Park on February 20, 1892, initiated the South's oldest gridiron rivalry. Cliff Hare led his team's shout: "Rah, rah, ree, Rah, rah, ree, Alabama AMC." Playing in a "sea of mud" because of heavy rains, Auburn won 10-0 and received a silver trophy. When the team returned to Auburn, proud fans fired the college cannon in their honor. Football fever swept the state. The series continued, and an Auburn player later summarized the importance of beating Georgia: "Let everything else beat us, and win from Georgia, and we had won all. Win all, and lose to Georgia, and we had lost all."

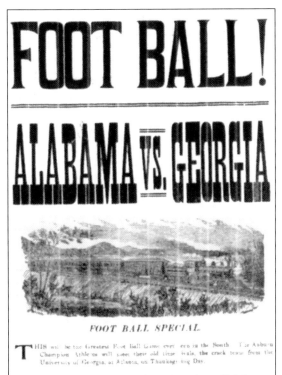

FOOT BALL!

ALABAMA vs. GEORGIA

FOOT BALL SPECIAL

THIS will be the Greatest Foot Ball Game ever seen in the South. The Auburn Champion Athletes will meet their old time rivals, the crack team from the University of Georgia, at Atlanta, on Thanksgiving Day.

THURSDAY, NOVEMBER 26TH, 1896.

Both teams are in better trim this year than ever, and the contest will be a battle royal. Five thousand people will watch the gladiators in their fight for supremacy. The game will be called at 2 o'clock at Brisbin Park.

On this special there will be no overcrowding and packing of persons into the cars, but every person will be comfortably seated.

Tune—"Two Little Girls in Blue"

There came an eleven from Auburn town,
 The best that had been there for years;
And the duty of this eleven was,
 To put old Georgia in tears.
There was Culver and Pearce, and
 "Blondy" Glenn,
And Stokes and Penton too,
And many others with us came,
 Who wore the orange and blue.

 CHORUS—
Eleven little tiger boys, lad,
 Eleven in orange and blue,
Everyone's brothers, and their mothers,
 Just knew what they could do;
And eleven little tiger boys, lad,
 Will break poor Georgia's heart,
They are another, that we will smother,

On goes Auburn down the field to goal,
 The Georgia boys are wondering why.
They never have been told
 That in Alabama,
Down in Auburntown,
 A football team, by Heisman trained,
Should bring old Georgia down.
 CHORUS.

He's our trainer from U. P.'s hall;
 What of football he don't know
We havn't missed at all.
 Hall was good, and Harvey
Made Auburn play like sin,
 But under Heisman's watchful eye,
Old Auburn plays to win.
 CHORUS.

FIGHTING WORDS. The lyrics of this song celebrated Auburn's potential for triumphing over Georgia and inspired players and coaches to prove they were better than their rival. Although the rivalry might seem bitter, the schools have shared a respectful relationship with alumni of each school coaching at the other, such as Auburn's star player Vince Dooley serving as Georgia's national championship–winning head football coach and athletic director. The school's athletic departments held a centennial celebration of their rivalry on February 20, 1992, at Piedmont Park.

UNDERDOGS. No one expected Auburn to beat Georgia when the teams met in Atlanta on November 29, 1900; therefore, Auburn's 44-0 victory stunned the crowd. Team captain Dan S. Martin declared, "We won because we were in better physical condition than the Georgia men and because our work both on the offensive and defensive was far above the work of the Georgia team." Martin continued, "Our men have trained conscientiously all season, and have obeyed Coach [Billy] Watkin's instructions to the letter, and we were therefore able to play a harder game than Georgia."

WIRE. Auburn players, such as 1908 captain J.T. "Tom" McLure, sent telegrams to family and friends living too far away to attend games. In just a few words, McLure conveys his jubilation at shutting Georgia Tech out. The Auburn-Tech rivalry began on November 25, 1892, when Auburn won 26-0, and became a Thanksgiving tradition. Every year, according to the yearbook, "On Turkey Day Auburn moved to Atlanta, all of the stores and shops were closed up, there was not one thing of consequence in the wide world to the students and townspeople other than the Auburn-Georgia Tech game."

MUSIC TO TIGER EARS. This song rejoices in Auburn's talents at conquering Georgia on the field. To prepare the Tigers for Georgia, Coach Donahue "worked with the men as never before. In the pale light cast by several tungsten on Drake field, he had the scrubs to hammer away hour after hour at the varsity line." The *Plainsman* wrote that the Tigers "fight for Mike because they love him . . . the glory goes to Mike."

Our College Song

Tune—"Marching Through Georgia."

RALLY 'round our colors, boys, and sing our college song —
Sing it with a spirit that will cheer our team along —
Sing it as we used to sing it in Ninety-five,
When Auburn won the game from Georgia.

CHORUS:

Hurrah, hurrah! Victory is our cry
Hurrah, hurrah! for the team from A. P. I.
They will win this victory,
Or trying they will die —
Yes, Auburn will win the game from Georgia.

"The famous Georgia 'Crackers' are sure to win the day,"
So the Goober-grabbers said — but it was not that way.
Had they not forgot, alas! to reckon with their host —
For Auburn was playing against Georgia.

Old "Heis" is a bird and Old Mitcham he is, too —
And on them you can depend to protect the Orange and Blue!
And with our little Tiger team Old Auburn need ne'er fear
That any harm may come to them from Georgia.
Break through the line and tackle hard and low!
Hold tight your man and do not let him go!
And down them in their tracks — they haven't got a show —
For our team is a warm one, you know, "my baby!"

When you see Alabama take the ball.
Tackle low and watch the "Crackers" fall.
And when the game is o'er naughty-to-naught will be their score
And "there'll be a hot time in the old town tonight!"

There are no flies on us there are no flies on us!
There are no flies on us — no flies on us!
There may be one or two big fat flies on you —
There are no flies on us — no flies on us!
So say we all of us so say we all.

Old Auburn has a foot ball team that's not afraid of the devil,
Hi rickety bilo, humpty-doodle-day!
Neither is she afraid of Georgia for her head is level,
Hi rickety bilo, humpty-doodle-day!
But when you hit Old Auburn's line you will find it is a baker,
Hi rickety bilo, humpty-doodle-day!
Auburn has a cracking team whose work will always tell, sir
And when they hit that Georgia line they will simply give it — sir
Hi rickety bilo, humpty-doodle-day!

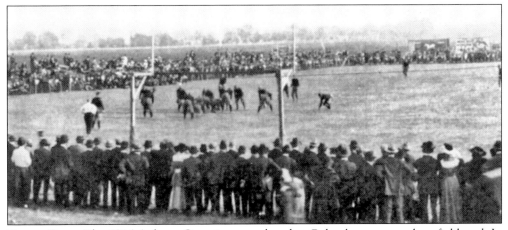

THREE-ZERO. The 1916 Auburn-Georgia game played at Columbus was won by a field goal. In Auburn before the game, "during the still hours of the night some loyal supporter flooded the town with placards bearing such inscriptions as "Georgia 0, Auburn ?". Fans rallied behind the Tigers and "crowded mass meetings at Langdon Hall and full bleachers at practice seemed to stimulate the team and no practice was too hard." In the second half, Richard Joseph "Moon" Ducote placed his helmet on the 47-yard line to use as a kicking stand. Fan Alma Smith Stoves (Class of 1919) recalled, "When Moon Ducote kicked that field goal you could have heard a pin drop. Then everything broke loose." As the crowd watched, "The ball went true and Georgia's hopes were smashed."

VANDY. Vanderbilt was another early rival, first playing Auburn in 1893, when Auburn won 30-10. Competition was intense and dangerous, and players were occasionally seriously injured. Hugh Bickerstaff (Class of 1895) shared his memories of the rivalry: "In Nov. 1894—played right guard against Vanderbilt in Montgomery—they ran all around me—over me—and finally broke my right jaw bone and that ended my foot ball career." George Alfonso Wright took this picture of Auburn's Main Gate and Toomer's Corner after the Tigers defeated Vanderbilt in November 1917. That corner is named for alumnus Sheldon Toomer, who played on Auburn's first football team.

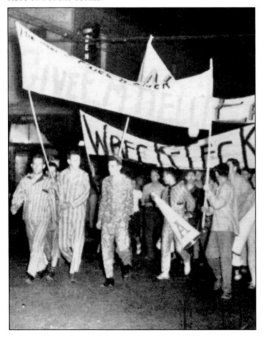

WRECK TECH. Auburn students enjoyed parading through campus and downtown before games with rivals. For decades in the 20th century, the Wreck Tech parade was a tradition prior to the Georgia Tech match. Students wore pajamas and carried floats that were taken to a designated point for a bonfire and pep rally. Students pictured here marched in 1938. The Auburn-Tech rivalry was bitter at times, especially because most of the games were played at Grant Field in Atlanta. Auburn lacked the home field advantage until 1896, 1898, 1899, and 1904 when Tech traveled to the Plains. George Alfonso Wright commented, "During the time of our old wooden gymnasium, Auburn's games with Tech usually wound up with Tech coming out second-best." Students began participating in the Wreck Who? LSU Parade when the Wreck Tech tradition ended in 1987.

"Trouncing" Tigers. Headlines the day after Auburn trounced LSU 28-6 at Legion Field on November 12, 1938, read "Bayou Bengals Badly Beaten." The "favored Tigers from L.S.U. suffered a most humbling defeat," while the "Tigers from the Plains were complete masters of the situation, and had won the game before it had reached its third minute." When the fourth quarter ended, "one Tiger has given the other the worst licking he has had in seven years." The first time Auburn played LSU was in 1901, and Auburn won 28-0 in Baton Rouge. In 1913, the LSU Bayou Bengals' only defeat was by Auburn, who won 7-0 at Mobile. Auburn beat LSU at Baton Rouge 21-7 in 1939, "all the Tigers were clawing with gusto." The 1994 Auburn-LSU game was exciting because LSU was ahead 23-9 at the start of the fourth quarter and then Auburn made five interceptions to win 30-26. In 2002, Auburn beat LSU 31-7 at Auburn.

Media. The student newspaper, *The Plainsman*, delighted in describing Auburn's victories over rivals with cleverly worded headlines that boasted of the Tigers' talents and demeaned opponents. Slogans such as "Fight for Mike and the Team" were printed prominently on mastheads. An image of All-Southern end David "Gump" Arial, who played on Auburn's undefeated 1932 team, cavorts over the headlines.

UNDERDOGS. Fullback James A. "Big Jim Reynolds pounds over for the score . . . [Frankie] Sinkwich on the left, [Monk] Gafford on the right" to help the Tigers demoralize Georgia in a 27-13 upset at Columbus in 1942. Because Georgia was scheduled to play in the Rose Bowl, "This was the game that rocked the nation, and brought Auburn the acclaim of the football-minded world. There was never any doubt in the minds of Auburn's supporters, after their team had matched Georgia's quick opening touchdown, that great things were to come. . . . It was a great day for the rampant Tiger."

NAIL-BITER. The Auburn campus provided a backdrop for the Tigers 14-13 vanquishing of Florida at Homecoming in 1951. The Tigers first played Florida at Auburn in 1912, winning 27-13. In 1951, as stated in the *Glomerata*, "with something less than four minutes available, Jack Creel proved himself the giant of the day, despite his 137 pounds, by blocking a Gator punt." Auburn quarterback Allan Parks and end Lee Hayley managed to score a touchdown with the recovered ball. "[Joe Brown] Davis, of course, split the uprights, and as he did so, cushions from the spectators sailed fieldward and those armed lifted flasks mouthward."

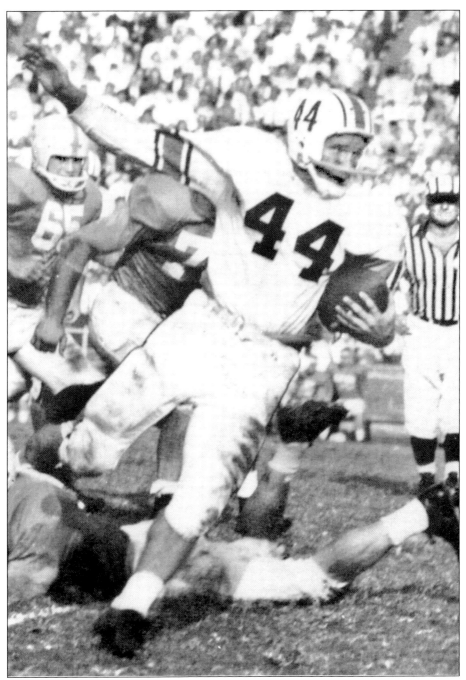

OPPONENT—ZERO. Fob James contributed the first touchdown to Auburn's 35-0 shutout of Georgia at Columbus on November 12, 1954. Jim Pyburn added two touchdowns, Joe Childress made a field goal, and James ran the ball in again. "After this Coach Jordan cleaned his bench," and Jim Walsh scored the final touchdown. When time ran out, Auburn was on Georgia's 1-yard line. Fumbling Georgia had been the SEC leader, "but the Tigers soon put an end to their championship thoughts." This team also kept Chattanooga, Florida State, Tulane, and Alabama from scoring. The 8-3-0 season record included a Gator Bowl win.

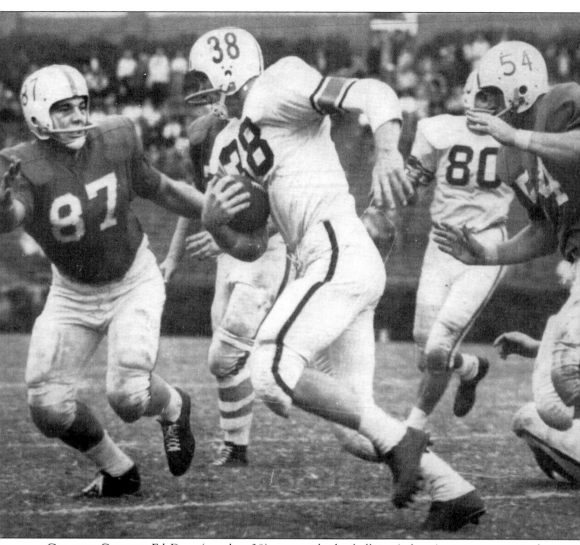

GIG THE GATORS. Ed Dyas (number 38) runs with the ball in Auburn's victory over rival Florida at Gainesville in 1958. Auburn "humbled the University of Florida by the baseball score of 6-5 before 37,000 fans." Dyas was named an All-American in 1960.

DIVERSITY. Auburn's first African-American player, James Owens, significantly contributed to a 9-2-0 season in 1970. He scored this touchdown in Auburn's domination of Florida in the 1970 game at Gainesville, which Auburn won 63-14. Auburn's integrated team strengthened football on the Plains.

RUNAWAY TIGERS. The Florida Gators did not have a chance when they played Auburn at Jordan-Hare on October 30, 1971. Auburn ran the score up to 40-7. With only seconds to go, Florida was stuck midfield with no possibilities for redemption. Auburn had a 9-2-0 season.

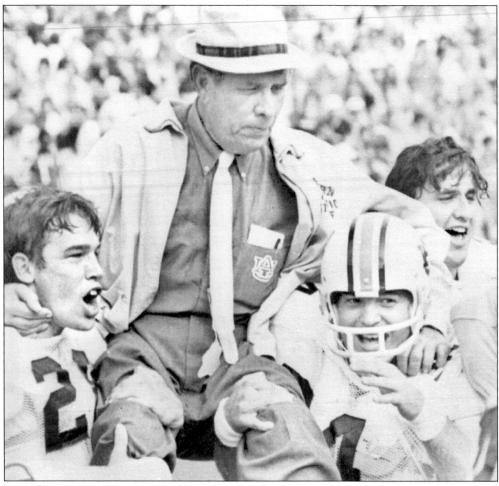

JOY. The Tigers were ecstatic in 1971 when they beat Georgia 35-20 at Athens, lifting Coach Jordan onto their shoulders to carry him on the field. Jordan's first victory against Georgia occurred in 1953 when Auburn won 39-18. The next year Auburn bested Georgia 35-0, and Dennis Smitherman wrote in the *Mobile Press-Register* that "Georgia's touted defense was shredded like hamburger in a meat grinder by a brilliant and versatile Auburn attack [in Columbus, Georgia] Saturday as the Plainsmen pulverized the Bulldogs."

HOME ADVANTAGE, AT LAST. When the Tennessee Volunteers finally traveled to the Plains to play at Jordan-Hare on September 28, 1974, Auburn blistered them 21-0. Auburn's defense kept the Volunteers under control, preventing them from crossing the midfield except one time. Tennessee's best players had limited, and even negative, rushing yards. "With this game, the Auburn defense became number one in the nation," the *Glomerata* reported, "and Liston Eddins was named national lineman of the week for his defensive end play." Auburn triumphed with a 10-2-0 record, including a Gator Bowl win.

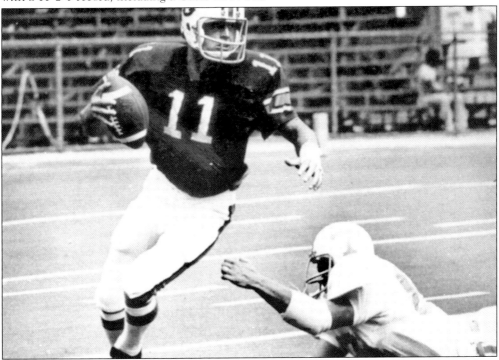

PERSONAL BEST. Quarterback Phil Gargis passed 224 yards and ran another 74 yards in Auburn's September 25, 1976 38-28 victory against Tennessee at Legion Field. His performance resulted in four touchdowns for the Tigers and surpassed his previous statistics. Irish soccer player, Neil O'Donoghue, whose name is reminiscent of Auburn's fabled "Iron Mike" Donahue, set an Auburn record when he kicked a 58-yard field goal during the first quarter. Television network ABC selected Gargis as the game's outstanding player.

57

THE HEDGES. Adlai Trone chews on a twig from Georgia's fabled hedges on the field after Auburn beat the Bulldogs at Athens 45-34 in 1997. In the 101st match between the longtime rivals, both teams demonstrated good offenses, generating high scores. Auburn's defense managed to curb Georgia from outscoring the Tigers. When Auburn won, "More than a few of the Tiger faithful took pieces of the hedges back with them to the Plains."

SWAMPED GATORS. When Auburn beat Florida 36-33 in 1994, the *Washington Post* printed the news in a headline above the paper's masthead on the front page. Florida was the number one team in the nation when the Tigers arrived at "The Swamp." The Tigers were behind, and the game seemed like a certain Florida win. However, Auburn player Brian Robinson's interception, as the fourth quarter had only a minute and 20 seconds on the clock, resulted in Patrick Nix capably passing the ball in four plays. Frank Sanders caught the ball to secure the victory for Auburn, much to the disgust of Gator coach Steve Spurrier.

FOUR

Significant Seasons

PERFECTION. Significant Auburn seasons have included winning streaks (1913–1915, 1919–1920, 1931–1933, 1956–1958, and 1993–1994) and historic events that impacted football. This drawing commemorates the 1914 season in which Auburn did not lose a game and tied in a scoreless match with Georgia. Repeating a Southern Intercollegiate Athletic Association championship, the Tigers followed in the paw prints of the 1913 team's perfect 8-0 season. Manager Jonathan Bell Lovelace exclaimed: "The season of 1914 is over. Auburn has humbled her opponents in her own state of Alabama, she has trampled over the bodies of the representatives of Florida, and shattered the hopes of the team from South Carolina; she has romped over the team from Mississippi A.&M., shut out the candidates from the Cracker State [GA], made the Commodore bite the dust, and defeated the invaders from the north; AND STILL HER GOAL LINE HAS NOT BEEN CROSSED!" The *Montgomery Advertiser* declared, "All Hail! To Auburn, Southern football champions of the 1914 season" for "fighting with grimness and determination which has characterized its gridiron battles throughout the season."

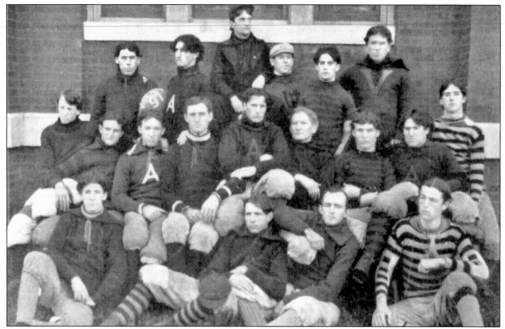

DANGERS. The 1897 Tigers were plagued by yellow fever. The disease spread in Alabama, causing some team members not to return to school because they or family members were sick. Others did not want to risk exposure by traveling. Auburn's schedule was affected when opponents refused to travel to game sites. Death abruptly ended Auburn's season when Von Gammon, a player from Georgia, died in a game against the University of Virginia and the teams decided to honor him by canceling the game. Auburn player George Oliver Dickey praised Gammon as a "true Southern gentleman, loved, honored and worshipped by his friends and respected by his opponents." The 2-0-1 season was a sad one for the Tigers.

GOODBYE, JOHN. The year 1899 was John Heisman's final season coaching on the Plains. His last Auburn team beat every opponent except Georgia (a tie) and Sewanee (a loss by only one point). He declared, "I never had a team at Auburn that I did not love." His legacy influenced Auburn players during the following seasons as Billy Watkins, R.S. Kent, Mike Harvey, and then Billy Bates coached the Tigers until Mike Donahue came to town. Heisman is still a presence on campus in the form of two Heisman trophies won by Auburn players; they are the only winners who played at a school where Heisman coached during his career.

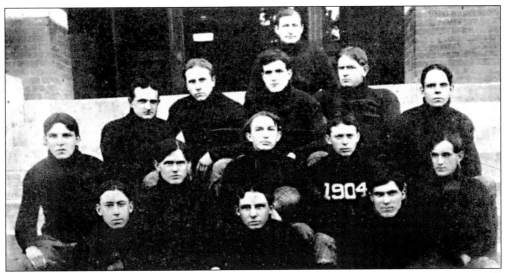

UNDEFEATED. Coach Donahue's first season in 1904 brought Auburn a victorious 5-0-0 record. Describing Donahue as charming yet demanding, a contemporary noted, "Donahue drove his teams with a light heart and a gentle lash, often killing his players with kindness instead of push-ups." Donahue expected his players to be committed to the sport, exhibit sportsmanship, and play "blood-and-guts football." During his career at Auburn, this Yale alumnus also taught physical education and mathematics classes and served as Auburn's athletic director.

ANNUAL BANQUET

IN HONOR OF

AUBURN FOOTBALL TEAM

Toastmaster...Prof. B. B. Ross

The College and Athletics...President C. C. Thach

A Successful Season...Coach Donahue

Old-Time Football...Prof. G. N. Mitcham

The Team of 1908...Capt. McLure

What the Scrubs Have Done for the Varsity...C. G. Gaun

The Student Body and Athletics...W. I. Pittman

The Ladies...Dr. George Petrie

IRON MIKE. The year 1908 saw Michael Donahue's return to the Plains after W.S. Keinholz had coached during Donahue's break the previous year. Donahue led this team to a 6-1-0 record. No team except LSU, which won 10-2, scored points against Auburn, and the Tigers shut out opponents with scores of 23, 42, and 44. The season foreshadowed the stellar championship teams Auburn fielded in the 1910s. This banquet program features leading names in both Auburn's and its football program's histories and probably was a feast of information to anyone fortunate enough to attend.

SOUTHERN CHAMPIONS. The 1913 team celebrated an 8-0-0 record and its first Southern Intercollegiate Athletic Association championship. Several players were named to the All-Southern team, including versatile team captain J. Kirk Newell, who "annexed more than a mile of yardage carrying the pigskin," and whom students chose as Auburn's best athlete that year. Auburn resident Bob Frazier was the team's "major-domo." During Auburn's early football decades, "he fired the coal furnace for hot water, swept the floors, hustled the buckets of water onto the playing field during times-out, massaged sore muscles, and rubbed horse-liniment onto bruises and sprained joints." Frazier accompanied the team to all games, home and away. "When some player was being revived, others gathered around the two buckets of water which had been brought onto the field," George Alfonso Wright recalled. "A large sponge was in each bucket. A player would run his muddy hand into a bucket, grab a sponge, lean his head back and bite into the sponge for a mouthful of water. Then with the wet sponge he would wipe the mud and sweat from his face, and toss the sponge back into the bucket for the next guy."

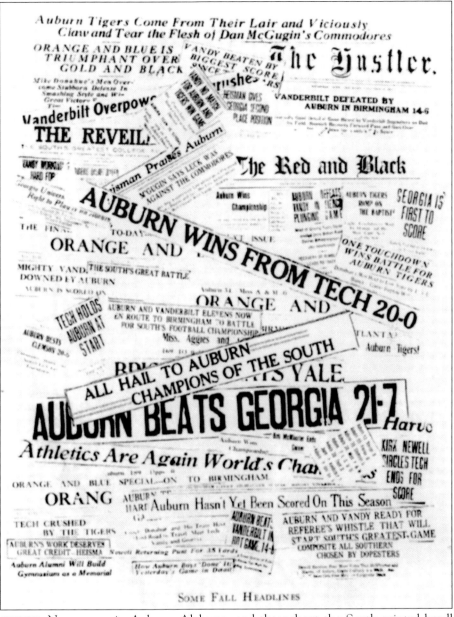

SOME FALL HEADLINES

HEADLINES. Newspapers in Auburn, Alabama, and throughout the South printed headlines boasting about the 1913 team's gridiron accomplishments. During the season, only Vanderbilt and Georgia scored points against Auburn. The Tigers beat all of their rivals. John Heisman, coach at Georgia Tech, publicly acknowledged his former team's prowess and the contributions of Coach Donahue, who gained a national reputation because of this championship. "The season of 1913 added another successful chapter to Auburn's long list of victories," Jonathan Bell Lovelace reported. When Auburn defeated Georgia in the season's final game, "It was just a fitting close to an extremely brilliant season, and the Auburn students rushed from the stands and carried the triumphant Auburn warriors off the field on their shoulders, while the band played an intermingling of 'Touch-down Auburn,' 'We will roll the old football along' and 'Glory, Glory dear old Auburn.'"

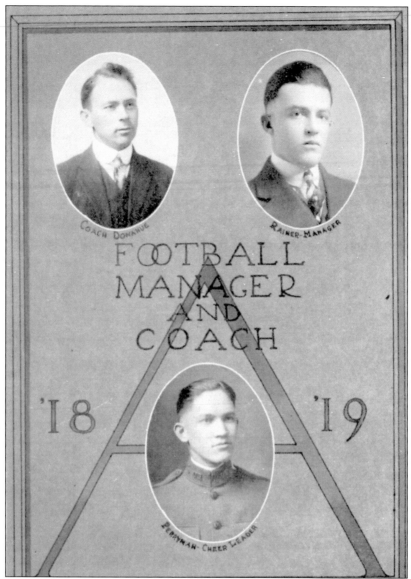

FOOTBALL
MANAGER
AND
COACH
'18 '19

Coach Donahue

Rainer-Manager

Berryman-Cheer Leader

WAR AND FLU. The 1918 team and staff faced several hardships. Many Auburn cadets, including football players, enlisted to serve in World War I. Then, the *Glomerata* reported, "The dreaded influenza arrived . . . and it became a question of not having any team at all, or of filling out the schedule with a crippled team. The latter course was chosen. For three weeks during the last half of October, there was football practice in name only." Some players became sick, while others had hospital duties as Auburn's population succumbed to the flu epidemic. "The players stuck bravely to it whenever they could, when regular practice became possible once more for what was left of the squad," the yearbook stated. The team persevered, playing a match with Camp Sheridan to raise money for the War Work Fund. Although the Tigers lost, "that never-dying spirit of an Auburn team was characteristic of the Tigers throughout the game," and Auburn's "little team" played as "the equal in spirit and fighting qualities of any Auburn team that ever stepped on a gridiron." Auburn survived to be 1919 SIAA champions.

PATRIOTISM. When the United States entered World War II, many Auburn football players, including Monk Gafford, Jim Pharr, and Jack Cornelius, and these men pictured, traded football uniforms for military uniforms. Throughout Auburn's history at that time, all male students attended compulsory military drills and were prepared for service. Alumni football players such as Col. Franklin A. Hart (Class of 1915) and Walter Gilbert (Class of 1936) also served in the war. A reporter commented about the players, stating "Who, if they play the same brand of ball for Uncle Sam as they did for Auburn, should make first rate fighting men." By 1943 a report noted "Auburn's coaching staff for football, in its entirety, is in the armed service and Auburn's lone football player from last year's squad could hardly carry on by himself," so the fall season was canceled. Members of Auburn's football squad were in all service branches and war theaters. Auburn football players fought in major battles and participated in significant invasions. They won medals and became heroes. They also suffered casualties, ranging from wounds and imprisonment to being killed or declared missing in action.

Football Picture Shown North African Soldiers

Auburn men in North Africa will have an opportunity to see the pictures of the Auburn-Georgia football game played last fall, due to the efforts of members of the athletic staff here.

After receiving word that an "African Alumni Chapter" had been organized by Capt. Ralph Jordan, former Tiger star and assistant coach, the athletic department conceived the idea of sending the film of this game to be shown to the Auburn boys stationed there. Through the efforts of Coach Wilbur Hutsell all arrangements were made. The film was classed as recreational material and put aboard an Army transport plane bound for North Africa.

If the Auburn boys stationed in North Africa have not departed for Sicily, Rome, and Berlin they probably have seen what happened to Sinkwich and Georgia's perfect record that Saturday afternoon in Columbus.

FAITHFUL FANS. No matter where they live, work, or serve around America and the world, Auburn fans faithfully follow Tiger football. The August 1943 *Home-Front News*, published by the Auburn United Methodist Church, reminded readers how important Auburn football was to fans serving around the globe during World War II. Football news comforted servicemen, and this film of Auburn's 1942 defeat of Georgia provided a welcome diversion. In May 1944, the newsletter reported, "The old 'War Eagle' came out of his year's hibernation last week," admitting "The old 'Eagle' may not be able to scream as loudly this year as he has done in the past—but scream he will." The editor commented, "Curtis Kuykendall, scat back in 1942, is the only letter man on the campus, and probably is the only man who can be counted on who has had previous experience at Auburn. The remainder of the team will have to be made up of 4-F's, discharged veterans, and new high school graduates." By summer, "football practice is going along at a double hot pace" and the team has "a great deal of confidence and spirit."

Plans are being made for a winning football team for this year. A total of 19 football players from Auburn's 1944 team have gone into the service since the end of the 1944 football season. However, new ones are being added to the squad. Coach Carl Voyles has two assistants, Tex Warrington, who was selected by All-American pickers as the best center in the country last fall, and "Shot" Senn who was formerly coach at Woodlawn High School, Birmingham. He is a former Tiger, finishing at Auburn in 1932. Bob Zuppke came to Auburn the week of July 4th to be a guest coach. He and Coach Voyles have been busy planning attacks and working out the team. Also added to the P.E. Department's staff is Coach Dan E. McMullen who is taking Shorty Propst's place as head line coach. McMullen, a native of Kansas, won three letters in football at Nebraska, and later played with the New York Giants, the Chicago Bears, and the Memphis pros. Until July 1, he was a civilian instructor at Navy Preflight school at Athens, Georgia. With such an experienced staff, and the makings of a great team, what else can we expect but a winning team?

FOOTBALL UPDATES. Agricultural engineering department head Dr. Jesse Neal sent a newsletter to Auburn servicemen and their families. Football was frequently mentioned as Neal reported on the status of the team. In July 1943, Neal stated, "The College Athletic Committee voted to discontinue intercollegiate athletics for the duration as all the coaching staff and all but one letter player were in the Service." By February 1944, he said, "Auburn is planning to have a football team next year but they may have to use girls. According to the new draft regulations, we don't expect to get many deferred students. There may be a game with the University if they will play." That fall, Auburn resumed playing to the delight of fans; when this newsletter was distributed in 1945, Neal expressed hope for Auburn's triumphant return as a football power.

Tributes. After President John F. Kennedy Jr. was assassinated on November 22, 1963, the American flag was lowered to half-staff at the Florida State game in Jordan-Hare. After the September 11, 2001 terrorist attacks, Auburn's home game, like others throughout the country, was cancelled the next Saturday, and the American flag in the stadium was lowered to display respect for casualties, including alumnus Mike Spann, the first combat casualty in Afghanistan later that year. At the Auburn-Alabama game, the universities' bands performed "A Salute to America" patriotic halftime show together. Before the August 30, 2003 Auburn-University of Southern California game, four Harrier jets from Marine Attack Squadron 223, three of which were flown by alumni, flew over of the stadium. The squadron had recently returned from duty in the Iraqi war. Sgt. Ian Hogg presented athletic director David Housel an Auburn flag he had flown on his vehicle while entering Baghdad.

SHUG'S TIGERS. The 1951 season initiated a new era of Auburn football. Alumnus Seth Gordon Persons (Class of 1922) named Ralph "Shug" Jordan Auburn's head football coach as his first gubernatorial action. Tiger fans had clamored for a new coach after several disappointing seasons, including a 0-10 record in 1950. Jordan conditioned his team and coached them to a 24-14 victory against Vanderbilt in his first game as coach. Auburn had not beaten Vandy since 1925. Zipp Newman of the *Birmingham News* wrote, "They can call 'em Tigers again—and mean it—a throwback to the Mike Donahue strain of Tigers that prowled Southern gridirons in the old days." Shug's team tallied four additional wins, beating Florida 14-13 in addition to defeating Wofford, Tulane, and Louisiana College. His inaugural season was the beginning of the Auburn rise to the top of American football with the *Glomerata* rejoicing, "[The] Plainsmen were playing SEC caliber football for a change."

AUSOME! Terry Bowden and Pat Dye rejoice as Auburn achieves a perfect 11-0-0 season during Bowden's first year coaching on the Plains in 1993. Bowden was named Coach of the Year. Because of NCAA sanctions, the team was ineligible for a national title and a bowl invitation; however, Auburn's undefeated 1993 team was celebrated by a variety of memorabilia; state newspapers and *Sports Illustrated* both printed collectible booklets. The team had many interesting members with ties to Auburn football, including acclaimed mystery novelist Ace Atkins, the son of 1957 National Champion team member Billy Atkins. The 1993 perfect season was part of a 20-game winning streak in 1993 and 1994.

FIVE

Team Spirit

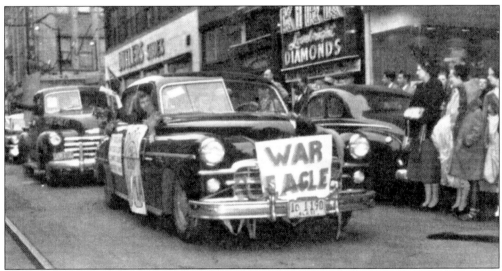

PARADES. This 1950 parade symbolizes Auburn pride. Auburn fans enjoy displaying their school spirit by decorating vehicles—from wagons and carriages in the early years of football to automobiles now—to parade prior to games. Young fans also decorate bicycles to show their support for Auburn. Orange and blue streamers, shakers, pennants, flags, and ribbons weaved around wheel spokes are frequently used. Fans paint signs and banners with slogans and Auburn's battle cry, "War Eagle," to hang on parade vehicles.

GO TEAM! J.G. Stanley drew this view of Auburn spirit in the stands and on the sidelines for the 1912 *Glomerata*. Although fashions may change over the years, Auburn spirit never goes out of style. Fans in each generation remain steadfast in their devotion to the Auburn Tigers. Every season is football season in Auburn, where people love football and follow news of recruiting, practicing, and other non-autumn football events. Tiger fans rejoice in Auburn football, supporting Auburn football every day of the year. Year-round dedicated players, coaches, athletic staff, and fans think about football, assessing past triumphs and preparing for future seasons.

FOOT BALL BENEFIT CONCERT.

Langdon Hall, Feb. 21, '96.

→>◇<←

PROGRAM.

"Cleon Waltz"—Henry	Mandolin and Guitar Trio.
"The May Bug"—Reading	Miss Greil.
Spanish Serenade—Lyngs	Miss Helen Mangum.
"Forester's Song"—Bishop	Male Quartette.
A Summer Night—Goring Thomas	Miss Wheeler.
(A) "Orange and Blue" Waltz (B) "Rip-Rap-Clog." } Original Banjo Solos	Mr. Smith.
Scena and Prayer—Der Freischutz	Miss Mamie Moore.
The Portion Scene—From Romeo and Juliet	Miss Greil.
"Old Mother Hubbard"—Ashford	Male Quartette.
"Ben Hur Chariot Race"—Paull	Mandolin and Guitar Solo.
"Summer"—Chaminade	Miss Wheeler.

→>◇<←

Male Quartette—
 W. M. Riggs, 1st Tenor.
 W. H. McBryde, 2d Tenor.
 J. Q. Burton, Baritone.
 J. B. Oglesby, Bass.

Mandolin and Guitar Trio—
 W. B. Kelly, 1st Mandolin.
 W. A. Hood, 2d Mandolin.
 H. A. Drennen Guitar.

FUND-RAISING. This benefit concert is an example of how, from the beginning, the Auburn community raised funds for equipment, uniforms, traveling, and other costs associated with their beloved Tigers. A news article advertising this concert stated it was "in honor of the completion of the new gymnasium, and for the benefit of the football debt." Commenting on the talented performers, the reporter stated, "This fact, combined with the fact that the proceeds will go to football will no doubt insure a large attendance."

College Yells

Auburn! Auburn!
Auburn! Auburn!
'Rah! 'Rah!
Anburn! Auburn!
'Rah! 'Rah!
'Rah! 'Rah!
'Rah! 'Rah!
Auburn!

What's the matter with Auburn?
Who-ha-hay!
She's O. K.!
Auburn! Auburn!
Who-ha-hay!

Auburn, Auburn is our cry;
V-I-C-T-O-R-Y

Rakete-yak, te-yak-te, yak,
Rakete-yak, te-yak-te, yak,
Zip, rah! Zip, rah!
Here we are. Here we are,
Auburn!

College Songs

Alabama, Alabama,
As the bells go jingling on
Alabama, Alabama,
As the bells go jingling on,
Will they be ours, oh yes!
Will they be ours, oh yes!
And we'll wipe them out Thanksgiving afternoon.

Boula--boulah,
Boula--boulah,
Boula--boulah,
Boula--boulah,
And we'll rough house
Poor old Georgia.
We will hollow
Boula--bou, rah-rah-rah.

We'll roll the old foot ball along
We'll roll the old foot ball along
We'll roll the old foot ball along
And we won't hang on behind.
If --- is in the way, we'll roll it over them,
If --- is in the way, we'll roll it over them,
If --- is in the way, we'll roll it over them,
And we won't hang on behind.

YELLS AND SONGS. Auburn's YMCA *Students' Hand-Book 1902–1903* printed these yells and songs for fans to cheer the Tigers during games and pep rallies. While seeming somewhat old-fashioned to modern fans, these ditties share the same spirit, themes, and rhythm as traditional cheers heard at every game. In the early 20th century, Auburn students practiced yells in Langdon Hall because the "Auburn team consists of two parts, one part, the squad on the field, and the other, the squad on the bleachers."

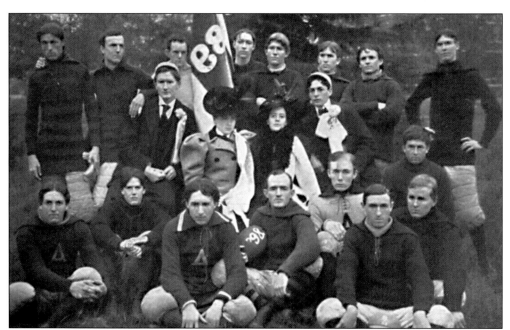

FOOTBALL SPIRIT. Students who were not selected for the varsity team often played on their class teams. The class teams played each other for the right to be named school champion. The 1898 senior class team, including coed sponsors, celebrates its championship with a team photograph taken in Samford Park. Class competition was the predecessor of modern intramural teams.

LOYAL. Alma Smith Stoves (Class of 1919) was a devoted Auburn fan her entire lifetime. After moving to Auburn in 1913, she reminisced 60 years later, "I've been going to football games here ever since I can remember. I think I cut my teeth on a football. I was going to games when Mike Donahue was coach." She attended consecutive home, away, and bowl games for years: "Football is my love. I'm always so glad when football season starts. It's just a thrill to see Auburn play. Win or lose, I'm with them." Alma stressed, "I want to be in the crowd." She was a cheerleader chaperone, her daughter Emaleen Stoves Fagen (Class of 1950) was a cheerleader, and her son-in-law Arnold Fagen (Class of 1950) was a football star. Her love for Auburn football has passed to all her descendants.

Tiger Teeth

These are the teeth of the Tiger's jaw,
 The men who fight and win;
Ever following the Sportsman's law,
 Fight to death, but never give in.

They're strong, tried, and true;
 They're men among men;
Faithful to the Orange and Blue.
 The Tiger's teeth to the end.

FIERCE. The *Glomerata* often printed short poems such as "Tiger Teeth," which appeared in the 1928 yearbook. These verses stressed Auburn's ferocious nature on the field and could be chanted loudly to intimidate foes and embolden players.

73

The Auburn Football Team

The deeds of the strong are immortal,
Heroic forever they live,
Eternal reward do they give.

Auburn, thy sons are heroes;
Under the Orange and Blue
Beats not a heart but is true.
Under thy flaming colors
Rise we to do or die—
Not one of us but will try.

Football, in which we shall conquer,
Our means of revenge shall be
Over all who shall dare to question
Thy glorious sovereignty.
Break forth, ye stalwart giants,
And carry our ball to the goal;
Loud then will our shouts be of victory,
Lo, the greatest that ever was told.

Team, may you always conquer!
Ever the victory win,
And we our support do pledge you,
Mighty and brave-hearted men.

TRIBUTES. Creative students often praised Auburn's football teams by writing poems, such as this one that appeared in the 1911 *Glomerata* yearbook. Although the words are flowery, the same thoughts, emotions, and pride are still held by dedicated Auburn fans almost a century later.

ART. Auburn's football team inspired students to create artistic depictions of players. Auburn kickers were favorite subjects for Auburn artists. Auburn's skilled kickers have often won games for Auburn by scoring an extra point with seconds left in what had been a tied game. George Augustus Miller (Class of 1916), a St. Augustine, Florida chemistry/metallurgy major, drew this kicker. His sketch shows the typical football uniform of canvas knickers, striped jerseys, socks, cleats, and no helmets in the 1910s. When he was not drawing for the yearbook, Miller painted his artistic contributions on the side of Auburn's water tank.

TEAM SPONSORS. During the first decades of Auburn football, before female cheerleaders were allowed, coeds and faculty wives sponsored teams for specific games such as these 1921 varsity sponsors. Longtime Auburn treasurer Allie Glenn was the first team's sponsor in 1892. Fifty years later, she was honored for her enduring team support when "she sat in the stands and received the plaudits of the spectators and players." The *Glomerata* praised coaches' wives Mrs. Dave Morey and Mrs. John Pitts because "these two faithful ones not only followed the Tigers to the field of battle on the week-ends, but daily slipped by the closed gates of Drake Field to watch and encourage them in their daily preparations. Hurray for our sponsors!" Sponsors occasionally participated in halftime ceremonies.

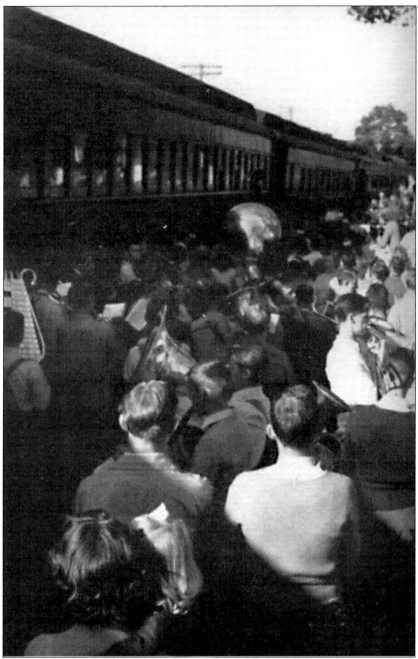

DEPOT. Before buses and airplanes were used to transport football teams, coaches, and staff, crowds gathered at Auburn's depot to wish teams well when they departed on trains for away games and to welcome them home whether they won or lost. "The student body never failed to be on hand," the 1928 *Glomerata* reported. "It's very familiar to see the crowd at the station on the week-end ready to leave with the team . . . They are allowed to go to four major games off the campus without getting the cuts." In the 21st century, fans, including students (Students Behind the Team), can arrange for group travel to away games in buses chartered by Tigers Unlimited.

TICKETS. In this photograph, students and fans line up to buy tickets at Petrie Hall for 1942 season games. In addition to assuring admission to games, these tickets are collectibles. Ticket designs incorporate such campus symbols as Samford Hall and information that documents Auburn's football history.

SPOILS OF VICTORY. On November 21, 1942, fans flaunt a goal marker taken from the field after Auburn beat Georgia's undefeated team. Crowds roared as "an inspired Auburn 11 played devastating football. With Monk Gafford stealing the show from Georgia's All American, Frankie Sinkwich, the Plainsmen came from behind to score in the first period following an 80-yard drive. They didn't let up, literally tearing the Bulldogs apart." The 27-13 victory celebration resulted in fans tearing the goalposts down and taking them to a downtown Auburn barbershop for everyone to see. This goal marker was strung from Auburn's Main Gate on Toomer's Corner. Although Auburn fans have been known to still take souvenirs from games, by the 1960s, rolling Toomer's Corner has become the preferred post-victory ritual. The web site, http://www.ToomersCornerLive.com, provides real-time rolling for fans who cannot travel to Auburn to participate.

IN THE STANDS. As male students, staff, and faculty left Auburn's campus to serve in military positions during World War II, the stands were filled mostly with coeds cheering the remaining Tiger players. Some male fans wearing military hats and uniforms can be seen. Team spirit endured despite the global conflict. When football was cancelled for the 1943 season, Auburn presidential executive secretary Ralph B. Draughon wrote, "There is no football this year—but we are having an old-time pep meeting, band, cheerleaders and all—out in the stadium this week—giving yells for a phantom team and a phantom student body which today is scattered all over the world."

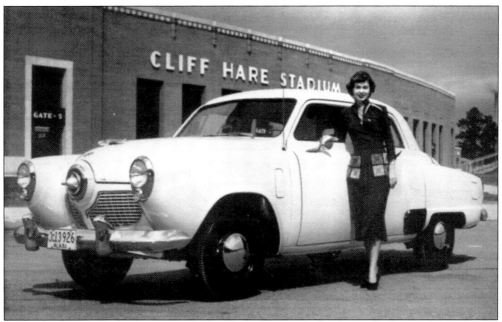

STYLE. Football became a favorite subject for advertisers as in this 1951 Studebaker advertisement sponsored by Birmingham's Cruse-Crawford Manufacturing Company. The company counted on the pretty woman and stadium to encourage fans to visit car dealers, take test drives, and invest in that automobile. Since then, advertisers in football programs frequently woo customers with stylish football themes, hoping their public team support and spirit will attract business.

HALFTIME. Auburn's band first included majorettes in 1946. Five coeds became majorettes after auditioning to show their baton twirling skills. The band's halftime performances were enhanced when a flag corps was established in 1985. Both groups practice routines to move in sync with the band's songs and marching patterns.

TIGER WALK. The Tiger Walk has its origins in the first games, when Auburn fans gathered to welcome the players and coaches to the field. This 1952 picture shows the formal lines of a military honor guard that greeted the team as it walked onto the field of Cliff Hare Stadium before the stadium was enclosed. The modern Tiger Walk emerged in the 1960s when coaches encouraged children to line Donahue Drive and Roosevelt Avenue as players walked from the newly built Sewell Hall athletic dormitory to Jordan-Hare Stadium. Gradually, crowds grew, and an estimated 20,000 people participated in the 1989 Auburn versus Bama pre-game Tiger Walk. At every home and away game, Aubie and the cheerleaders lead the team and coaches to the stadium. At Auburn, players pass through the Tiger Walk Plaza, where 6,000 inscribed bricks lay, to the locker room. Players credit the pre-game experience with boosting their spirit and adrenaline to play their best.

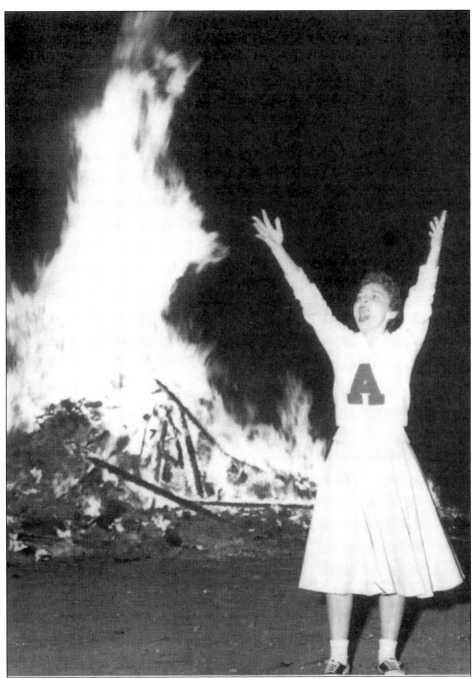

BURN THE BULLDOGS. Many Auburn parades and pep rallies conclude with floats being tossed into bonfires. One of the fieriest annual rallies is held before the Georgia game. For decades, Auburn students have built floats depicting bulldogs then have delighted in seeing the flames destroy them. Other teams' crepe paper mascot replicas meet similar fates. The fires are usually staged at fields near the edge of campus so that sparks do not endanger buildings. The bonfires illuminate the dark autumn nights as cheerleaders encourage the crowd to yell to intensify spirit and demonstrate their support to the team.

RAH! Male cheerleaders have led cheers since Auburn's earliest games. At the 1907 Clemson game, Leland Cooper (Class of 1907) and Auburn's six other coeds decorated orange hats with blue letters that read "V-I-C-T-O-R-Y" when they sat in order. They sang songs at halftime because they "thought football was wonderful and [they] loved Coach Mike Donahue and the Auburn team." Their cheers helped Auburn win 12-0. Women first formally joined Auburn cheerleading squads in 1937. On the sidelines, cheerleaders, like this 1959 squad, encourage fans to shout and boost players' morale by performing routines and directing appropriate crowd responses to game action. Cheerleaders also build school spirit at pep rallies and in parades. The following cheerleaders are pictured from left to right: (front row) Kenneth McLeod, head cheerleader Jerry Max Barnes, Ray Duncan, and Joe Ed Voss; (middle row) Ophelia Jones and Janice Hipsch; (back row) Nancy Walker. Alternates Tommy Crawford and Gayle Jones are not shown.

A-DAY. Every spring, players report to drills in order for coaches to assess their potential for the upcoming season. At the conclusion of this intense training and conditioning period, players are assigned to two teams, Orange and Blue, which participate in an intra-squad meet known as A-Day. For centennial festivities, Auburn's Team of the Century; Player of the Century Tucker Frederickson, a 1961 All-American; and Coach of the Century Shug Jordan were honored at the 1992 A-Day game. Fans eagerly watch the annual A-Day game to see how favorite players are performing and to debate whether that will be the year that Auburn wins another national championship. Coach Jordan credited spring training with producing Auburn's national champion and other victorious teams.

DREAMS. Many boys aspire to play football for Auburn, and very summer hundreds attend Auburn football camps. Two children's books, C. Bruce Dupree's *Coming Home Auburn!* and Buddy and Marsha Scott's *Gameday* (with Karl Franklin's illustrations), show how exciting Auburn football is for young fans. Children reenact notable Auburn football moments on playgrounds throughout Alabama. On Fan Day, children can meet players, get autographs, and have their pictures taken with their gridiron heroes. The Auburn Athletic Department has an Auburn Tiger Kid's Club (http://www.AuburnTigers.com/KidsClub/).

CORSAGES AND CROWNS. Homecoming is a time when Auburn spirit and traditions peak. The student body elects a queen who is presented with her court at halftime. Janice Hipsch, the 1958 homecoming queen, is pictured with Phil O'Berry and 1957 Miss Homecoming Evelyn Ray. Halftime ceremonies often feature such special events as retiring jerseys or honoring notable players, coaches, and visitors. Royal Air Force officer William M. "Bill" Goodall was stationed at Maxwell Field when he met Monk Wright, who invited him to Auburn's 1941 Homecoming. Goodall wrote: "On Saturday the whole town was en fete for the last day of the College football season, known as Homecoming Day, and all the Fraternity houses were decorated for the occasion." He reported, "Before the game the announcer welcomed the few RAF cadets who were present and this was warmly applauded. We all enjoyed the game itself in spite of our ignorance of American Football rules and as Auburn comfortably won by 28-7, everyone was happy." The University Program Council's Tigermania, offering a week of activities, concerts, dances, and fireworks, precedes modern homecoming games.

TIGERETTES AND TIGER HOSTS. Auburn established the Tigerettes in the spring of 1977. These coeds are the official hostesses of the athletic department. They help with football banquets and recruiting. Male Tiger Hosts were added later. They accompany recruits and their families to home games and A-Day, and during official visits, guide them around campus and answer questions about Auburn. The War Eagle Girls and Plainsmen, Auburn's hostesses and hosts, also perform duties related to football. Both groups are selected for their friendliness, spirit, and enthusiasm for Auburn traditions. Coach Paul Nix said, "Nothing can inspire prospective athletes more than the Auburn student."

"GLORY, GLORY TO OLE AUBURN." The Auburn Band has been a campus tradition since 1897. The musicians and performers entertain football crowds. Originally established as a drum corps to accompany military drills, the band gradually began to play for athletic events, inaugurals, and other performances. The band plays pep songs unique to Auburn in addition to cultural favorites. Marching patterns include the formation of eagles, the outline of Alabama, and the letters "AU." The band traditionally played the "Auburn Victory March" until the fight song "War Eagle" was first played at the September 1955 Auburn-Chattanooga game. In 2004, Auburn's band received the esteemed Sudler Intercollegiate Marching Band Trophy.

WAR EAGLE. A stuffed golden eagle served as Auburn's mascot until a live eagle was caught in the nearby countryside in the 1930s. Since then, several eagles have served as the War Eagle with the approval of United States Wildlife officials. Campus lore included varying stories about the original eagle that inspired Auburn's battle cry, "War Eagle!" Several of the explanations are connected to Auburn's military heritage. War Eagle has been an important part of Auburn football, raising spirits by being present on the sidelines. Until the eagle's aviary near the stadium was dismantled in 2003, the site was a favorite pre-game place for fans to visit. Eagle trainers traditionally were members of Alpha Phi Omega service fraternity until the veterinary school's raptor center began housing the eagle in the 21st century.

PRESIDENTIAL FANS. Auburn presidents, such as Harry Philpott (pictured), enthusiastically attend games. Sometimes they host honored guests such as former United States President Jimmy Carter and his wife, Rosalynn, comedian Bob Hope, dignitaries, and Alabama governors and politicians. "We nominate [Auburn president] Dr. Bradford Knapp for the first All-American president," the 1928 *Glomerata* stated, because "an ardent, enthusiastic, and loyal follower of the team, he was often found on the bench with the players."

WINDOW SPIRIT. Students express Auburn spirit by painting store windows on Toomer's Corner and along College Street and Magnolia Avenue with messages and images. Specific games and events inspire the subject of window art, such as this portrait of Shug Jordan during his final season as head football coach. The artist is using an Auburn plastic cup distributed by stadium concession stands.

ENTREPRENEURS. This boy sells game programs to tailgaters and fans walking to the stadium. Many Auburn youth benefit by selling fans soft drinks and treats such as peanuts. Others offer to protect cars from thieves during the game while the vehicles are parked in lots and spaces nearby residents rent to fans. Autumn also brings the smell of barbecue to game days when cooks set up stands on the roads leading to campus.

AUBIE. Auburn's debonair tiger mascot, Aubie, is shown celebrating his 20th birthday at the 1998 Homecoming game. Students and alumni who have filled his paws surround him. Created by *Birmingham Post-Herald* cartoonist Phil Neel for a 1959 football program, the character Aubie has become a crowd favorite. The costumed Aubie first appeared in 1978 and has won the Universal Cheerleader Association's national mascot championship several times. Constantly on the prowl during games, Aubie waves the SGA Spirit Committee's large flag and cavorts with Auburn performers. Team spirit is always strong wherever Aubie is.

GAMEDAY. Fans wanting to avoid congested parking lots and long walks to the stadium can invest in Gameday Center Sports Condominiums (http://www.gamedaycenters.com, 1-800-693-8204) on Donahue Drive. Fans can purchase and/or rent a luxurious suite or private parking space close to Jordan-Hare. Gameday Center has a private clubhouse for use year-round, and members enjoy such activities as viewing bowl games.

SIX

Bowl Games

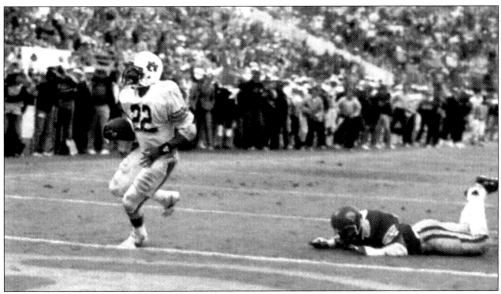

FIVE HUNDRED WINS! Auburn achieved its 500th football victory since the team was established in 1891 at the Citrus Bowl in Orlando, Florida, on New Year's Day 1987. Brent Fullwood dashed past a University of Southern California player to score one of two touchdowns he made that day. Auburn won 16-7, gaining its tenth bowl win for a 10-2 season.

AUBURN

LE	LT	LG	C	RG	RT	RE
Eaves 17	Roton 16	McCroskey 29	Gilbert 33	Gantt 32	Rodgers 20	Williams 12

QB
Scarborough
35

LHB
Fenton
25

RHB
Hitchcock
24

FB
Kilgore
46

SQUAD LIST

No.	Name	Pos.
10.	Milton Howell	End
11.	Pelham Sitz	Back
12.	Hamp Williams	End
14.	Osmo Smith	Back
15.	Norman Whitten	Guard
16.	Herbert Roton	Tackle
17.	Joel Eaves	End
18.	George Wolff	Tackle
19.	Kermit Weaver	Back
20.	Hugh Rodgers	Tackle
21.	Wesley Loflin	Guard
22.	George Gerakitis	Back
24.	Bill Hitchcock	Back
25.	Jimmy Fenton	Back
26.	Billy Ellis	Back
27.	Fred Gillam	Guard
28.	Ralph Sivell	Guard
29.	Sam McCroskey	Guard

No.	Name	Pos.
30.	Rex McKissick	End
31.	Malvern Morgan	Center
32.	Frank Gantt	Guard
33.	Walter Gilbert	Center
34.	Frank Hamm	End
35.	Sid Scarborough	Back
36.	Joe Stewart	Back
37.	Bob Coleman	Back
38.	Lester Antley	Center
39.	Bobby Blake	Back
40.	Thomas Edwards	Back
41.	Rabbit Karam	Back
42.	John P. Tipper	Back
43.	Fred Holman	Tackle
44.	Vernon Burns	Tackle
45.	Bo Russell	Tackle
46.	Wilton Kilgore	Back
47.	Bill Nichols	Tackle

No.	Name	Pos.
48.	Malcolm Crowder	Guard
49.	Francis Riddle	Back
51.	Dutch Heath	Back
52.	Ralph O'Gwynne	Back
54.	Bill Mims	Back
55.	Milton Bagby	Center
56.	Oscar Burford	End
58.	Garth Thorpe	Tackle
59.	Morris Cook	Back
60.	Floyd McElroy	Back
61.	Speck Kelly	Back
62.	Geter Cantrell	Back
63.	Everett Smith	Guard
64.	Lamar Hart	Back
65.	Ted Ferreira	Back
66.	Marion Walker	Back
68.	Julian Fowler	Back
69.	Lloyd Foster	Back
74.	Gus Franke	Back
75.	John Lowery	Back

BOWL DEBUT. Coach Jack Meagher and the Tigers traveled to Havana, Cuba, to play in Auburn's first bowl game. No United States collegiate bowls had been played in a foreign country before this event. Referred to as both the Rhumba and Bacardi Bowl, the game scheduled for January 1, 1937, was part of the Cuban National Sports Festival. Cuba was in turmoil because Col. Fulgencio Batista, the Cuba Army's chief of staff, had just overthrown the president of the Republic of Cuba, Miguel Mariano Gomez. Cuba's commissioner of sports, Carlos Henriquez, had invited Auburn to play but fled to Birmingham when Batista forced him to leave Cuba. The Tigers waited and distracted themselves with sports and socials, including Alabama Olympian Jesse Owens racing and defeating a local thoroughbred in a 100-yard dash. In addition to the names on this roster, Shug Jordan served as an assistant coach.

TROPICAL TIE. After the New Year's morning Festival of the Palms Parade, Auburn's players took the Havana soccer stadium field for the afternoon Havana Festival Game, which was the "feature event." An estimated 9,000 people watched the Tigers tackle the Villanova Wildcats. "Playing under a tropical sun" and "terrific heat," Auburn had the advantage because the Tigers were "heavier and more acclimated." Zipp Newman reported, "Billy Hitchcock streaked 40 yards for the Plainsmen's touchdown in the first period." The Villanova players were in a "state of virtual collapse. Players were taken out panting—exhausted." Frustrated players engaged in fistfights. "Auburn was playing under that same sun—but they had a taste of it before." Newman commented, "Auburn played in extremely hard luck and should have won by two touchdowns." Auburn players are pictured tackling Villanova fullback Jack Earle. Villanova scored in the fourth quarter, and the teams tied. Since then, Auburn teams, coaches, and fans have traveled to many states for post-season bowl competitions but have never played in any other foreign countries.

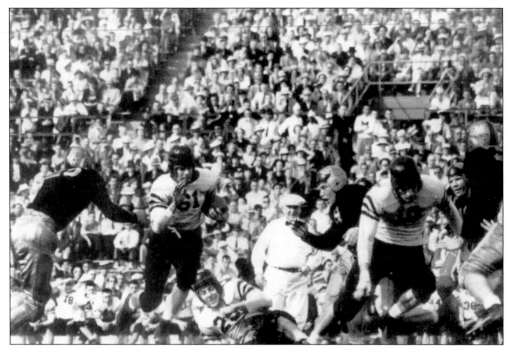

ORANGE BOWL. After the Tigers' strange trip to Havana, they attained their first bowl win. Coach Jack Meagher led his team to victory on January 1, 1938, at the Orange Bowl in Miami, Florida. Auburn defeated Michigan State 6-0. The championship capped a 6-2-3 season, in which they beat all of their main rivals except LSU and tied 0-0 in three games.

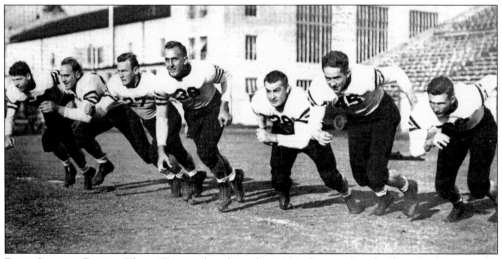

POST-SEASON PRIDE. These Tigers played in the 1938 Orange Bowl. Shug Jordan was the team's line coach. Jerry Bryan, writing for the *Birmingham Age-Herald*, reported, "This hard-hitting line took the bulky East Lansing forewall apart. The Tiger backs waded through their huskier opponents like they were junior college boys most of the time." At Auburn, a crowd gathered near the Main Gates at Toomer's Corner to celebrate.

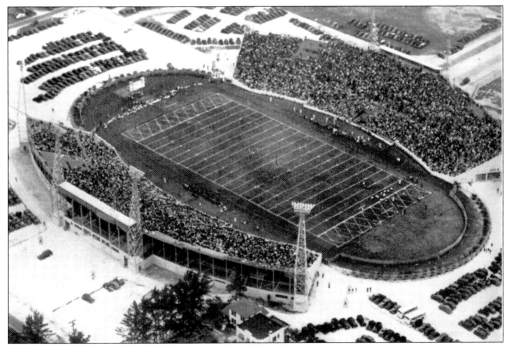

GATOR BOWL. The Auburn Tigers traveled to this stadium in Jacksonville, Florida, three times for post-season Gator Bowl games in the 1950s and set several Gator Bowl records. At their second Gator Bowl game, Auburn "resoundingly subdued" the Baylor Bears 33-13 on New Year's Eve 1954.

TEAMWORK. Together the Auburn Tigers effectively defeated Baylor in the 1954 Gator Bowl. Coach Jordan stated, "Our best defense was our offense." The "Plainsmen inched, then roared ahead; and as the smoke cleared, the Texans were trying to find just what had hit them." *Houston Post* sportswriter Jack Gallagher wrote, "Awestruck Baylor, helpless in the face of Auburn fury, was crushed by the warriors from Alabama, surely the best 13th place team in the United States." "Joltin" Joe Childress was selected the game's best player. Auburn enjoyed an 8-3-0 season, shutting out their oldest rivals, Georgia and Alabama, and effectively beating Florida State University 33-0.

TELEVISED. During the 1950s, Auburn's season and bowl games began to be broadcast on television such as this image from the 1955 Gator Bowl game shows. Cameramen for the networks became familiar sites on the sidelines and on top of the press box. Newsreels and bowl games gave the Tigers more exposure and enabled alumni and fans nationwide, and occasionally in foreign countries, to yell "War Eagle!" to television screens.

SUN BOWL. From left to right, Loran Carter, David Campbell, Coach Shug Jordan, Alabama Highway Patrol Lt. Louis Phillips, and Buddy McClinton celebrate Auburn's 34-10 defeat of the Arizona Wildcats in the December 28, 1968 Sun Bowl at El Paso, Texas. Campbell and McClinton were named the bowl's Most Valuable Players. Defensive players intercepted eight passes, including one Mickey Zofko ran in for a touchdown. At the end of the season, Auburn was ranked 17th nationally and Alabama was 18th.

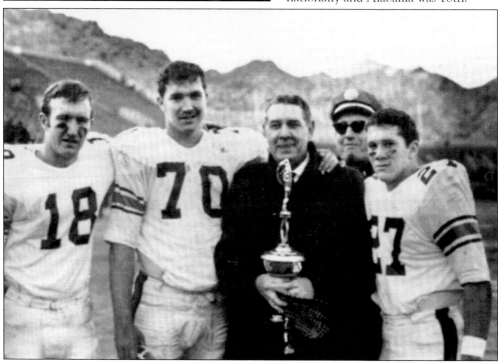

BASKING IN SUNSHINE. The Tigers enjoyed their day in the sun, beating Ole Miss 35-28 in the New Year's Day 1971 Gator Bowl at Jacksonville, Florida. A crowd of 71,138 watched as Pat Sullivan passed for 386 yards, breaking his personal record. He was named the game's Most Valuable Player. Auburn's 9-2 season record resulted in the Tigers being ranked number 10 in the nation.

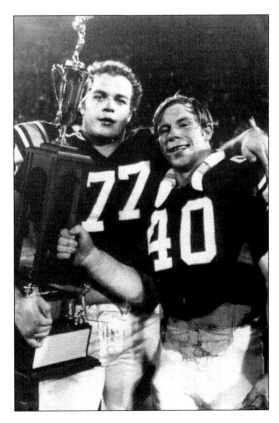

BEAMING TIGERS. The 1972 captains, Mac Lorendo and Mike Neel, son of Phil Neel (who created Aubie), proudly pose with the 1972 Gator Bowl trophy. Auburn defeated Colorado 24-3 on December 30 of that year.

APPROVAL. The Alabama House of Representatives passed this resolution, initiated by Auburn alumnus Rep. Pete Turnham, to acknowledge publicly its pride in the Tigers winning the 1971 Gator Bowl. The politicians noted the importance of the game being aired to servicemen for morale-boosting entertainment during the Vietnam War. Coach Jordan kept the copy of the resolution presented to him.

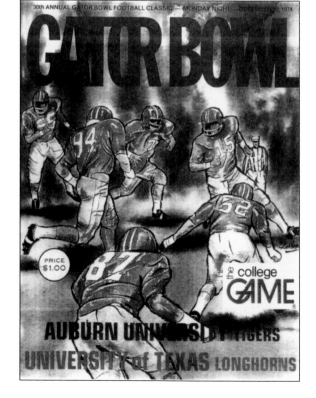

WRANGLING LONGHORNS. Auburn won the 1974 Gator Bowl versus the University of Texas on December 30; Auburn scored 27 points and Texas only 3. Auburn player Phil Gargis was named Most Valuable Player for that bowl game.

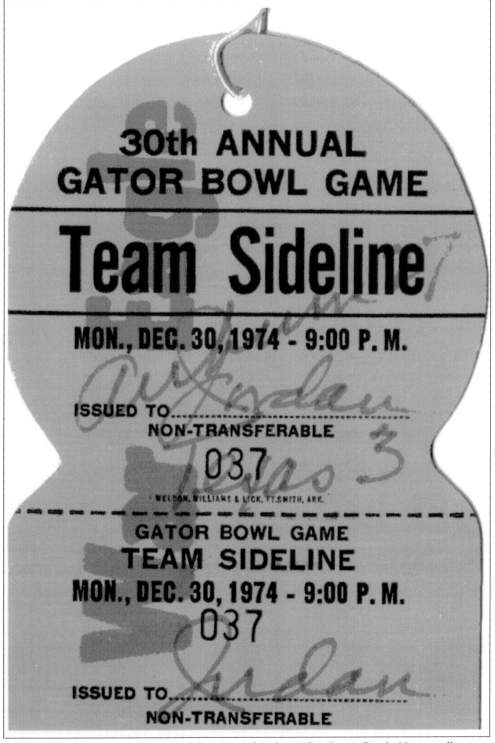

30th ANNUAL GATOR BOWL GAME

Team Sideline

MON., DEC. 30, 1974 - 9:00 P. M.

ISSUED TO..........................

NON-TRANSFERABLE

037

NELSON, WILLIAMS & LICK, FT. SMITH, ARK.

GATOR BOWL GAME

TEAM SIDELINE

MON., DEC. 30, 1974 - 9:00 P. M.

037

ISSUED TO..........................

NON-TRANSFERABLE

ACCESS. Shug Jordan saved his sideline pass for the 1974 Gator Bowl. He proudly wrote Auburn's score on the pass and saved it as a memento of a great season.

TANGERINE BOWL. After having not played in a bowl since 1974, the Tigers traveled to Orlando, Florida, where they beat Boston College 33-26 in the December 18, 1982 Tangerine Bowl. Heisman winner Doug Flutie played quarterback for Boston College that day. Auburn concluded the season 9-3-0 and ranked number 14 nationally. Coach Dye emphasized, "We could take this team right now and play anyone in this country."

HOW SWEET IT IS. Auburn players, fans, and especially Coach Dye were jubilant by the Tigers' 9-7 victory over Michigan in the January 1, 1984 Sugar Bowl. Kicker Al Del Greco. pictured, assured Auburn's win. Future Heisman winner Bo Jackson was named the game's Most Valuable Player. Auburn fans partied for days in New Orleans to celebrate Auburn's bowl win and SEC title.

LIBERTY BOWL. Auburn beat Arkansas 21-15 in the Liberty Bowl, which was the first time those teams played each other, at Memphis on December 27, 1984. Auburn's 9-4-0 season included several games lost only by a few points. Quarterback Pat Washington is pictured here.

DYE-TIED. Fans flocked to New Orleans when Auburn played in the Sugar Bowl again, creating a "flood of orange and blue in the Superdome and down Bourbon Street." Auburn and opponent Syracuse tied 16-16 in the January 1, 1988 Sugar Bowl because Dye chose to kick a field goal instead of running the ball with only one play and the score at 13-16. Auburn's kick was good, and the final score tied. Syracuse fans sent hundreds of ties to Auburn's Coach Dye, and he resourcefully auctioned them as a fund-raiser. Auburn was SEC Champion that year with a 9-1-2 record, also tying 20-20 with Tennessee.

HALL OF FAME BOWL. On New Year's Day, 1990, following Auburn's decisive defeat of Bama at Jordan-Hare, the Tigers defeated Ohio State 31-14 in the Hall of Fame Bowl at Tampa. Ohio State led 14-10 in the first half. According to the *Glomerata*, "The second half belonged completely to the Tigers," and Reggie Slack, who was named Most Valuable Player, guided Auburn to victory. Auburn ended the season with a 10-2-0 record and a SEC Championship.

PEACH BOWL. Auburn beat the Indiana Hoosiers 27-23 when they played at Atlanta's Georgia Dome on December 29, 1990. The Tigers gave the crowd a tense game that was won when Stan White scored a touchdown in the last minutes of the fourth quarter. Dye loudly cheered from the sidelines, and players and fans "exploded" with loud "War Eagle!" shouts. The victory assured Auburn the number 19 ranking in year-end polls.

SEVEN

Beat Bama!

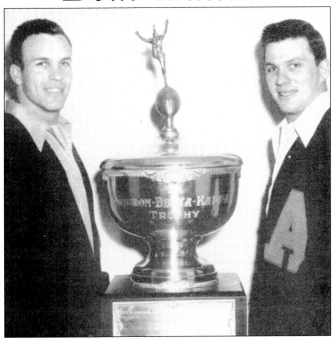

HONOR. Auburn beat Alabama 32-22 in their first match played at Birmingham's Lakeview Park on February 22, 1893, beginning Auburn's most intense rivalry. In 1949, captain Ralph Pyburn and center Coker Barton pose with the ODK-James E. Foy V Sportsmanship Trophy. Each year, this award is presented to the university that wins the Iron Bowl. Foy, an Alabama alumnus, was Auburn's Dean of Student Affairs from 1950 to 1978. The trophy is presented at halftime on the winner's home court at an Auburn-Alabama basketball game. Auburn and Alabama played from 1893 to 1907, when the schools disagreed about schedules. The series resumed in 1948 and was played at Birmingham's Legion Field until 1989 when the teams began to alternate home games. The Iron Bowl evokes strong emotions and intensifies school spirit. *Sports Illustrated* declared Auburn versus Alabama "the best rivalry in the land, bar none, for the year-round passion it generates in Dixie."

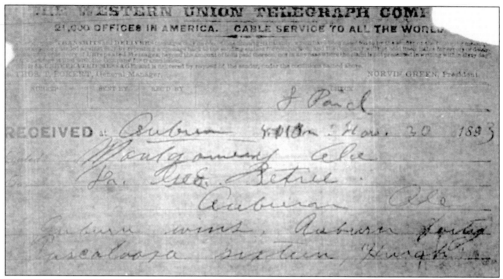

WIRE REPORTS. Because Auburn cadets were not allowed to leave campus to attend games when Auburn football began, they relied on telegrams to learn scores. This telegram from mathematics professor Otis D. Smith to George Petrie announced Auburn's second victory, 40-16, over the University of Alabama on November 30, 1893, at Montgomery. As technology advanced, students gathered to listen to games transmitted by wire. Leonidas Polk Sweatt (Class of 1915), who worked in the college power plant, stated, "Saturday afternoon football games away from Auburn were received over long distance and relayed to the audience in Langdon Hall chapel. A 25 cent admission fee was charged." He explained, "On those afternoons the power house telephone was disconnected and the telephone line to the plant tapped by a temporary line to [Langdon]."

"YEA AUBURN!" When the Iron Bowl was held at Birmingham's Legion Field, Auburn fans paraded downtown in that city to rally team spirit. Sportscasters nationwide consistently identify the Iron Bowl as one of America's most legendary football competitions. Iron Bowl games have added drama to Auburn's football traditions and created stories that have become part of Auburn lore. Prof. Dan T. Jones saw Auburn play Alabama in Birmingham when he was a boy. "There were red and white and orange and blue colors all over town," he reminisced. "There were many fights during the game" and at the Bijou Theater "to avoid being booed all performers had to wear both college's colors."

23-0 IN 1902! Auburn bookstore owner Robert Wilton Burton wrote humorous ditties glorifying Auburn's victories over archrival Alabama and posted his creations on the bulletin board in front of his store. He also published his writing in newspapers and magazines. His home was called the Four-Story Cottage because he built it with the profits from four stories he wrote. This verse appeared in his 1903 booklet, *Rhymes and Jingles: A Souvenir of Auburn.*

23

AUBURN *vs.* TUSCALOOSA, 1902.

Before the game had well begun
Some one asked: "Can Allison run?"
Before the game was fairly done
Exclaimed all: "Can't Allison run!"
Well, yes; I shouldn't like to say
How much he helped to win the day,
For every man played well his part,
Which made it a go from the start.
A goose-egg to the foe for dinner—
Tuska loser, Auburn winner.
So has it been since '94;
So may it be forever more.

—o—

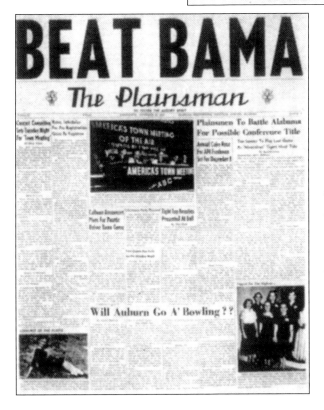

BEAT BAMA. The front page of the student newspaper, from when it was originally titled *The Orange and Blue* to currently *The Plainsman*, consistently printed football slogans in large type, especially when the upcoming game was versus Alabama. Headlines and stories, often on page one, reported before and after games, congratulating the team on victories and wishing them better luck the next season when Alabama prevailed.

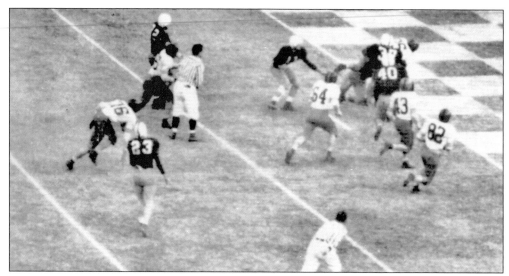

1949 VICTORY. Auburn beat Bama in the second game played after the series resumed in 1948. "It was a vengeful bunch of Auburn Tigers playing one of the greatest games in the history of Auburn football that upset mighty Alabama 14 to 13 before 44,000 delirious fans in Legion Field, Birmingham," the *Glomerata* reported. Alabama scored a touchdown but not an extra point in the game's "last breathless seconds." The "exhausted crowd" stayed at the stadium for two hours after Auburn won. Zipp Newman, *Birmingham News* sports editor, declared, "There has never been a sweeter Auburn victory in all the 58 years of football on the Plains than the Tigers 14-13 win over Alabama." The *Montgomery Advertiser*'s Max Moseley remarked, "Traveling Travis Tidwell, the SEC's most valuable player, proved his worth. The 185-pound Birmingham boy finished his grid career in a blaze of glory as he led his mates to victory."

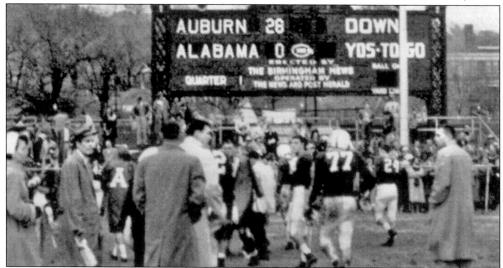

1954 VICTORY. The Legion Field scoreboard bears the 28-0 score when Auburn rolled over the Crimson Tide after a four-year dry spell. Zipp Newman reported, "Auburn rode the mercury heels of Bobby Freeman, Joe Childress, and Fob James to its most glowing victory over Alabama since 1904." Freeman scored three touchdowns and Childress one. Three players, Freeman (total offense), Childress (rushing), and Jim Pyburn (pass reception) secured conference season titles by the end of this game.

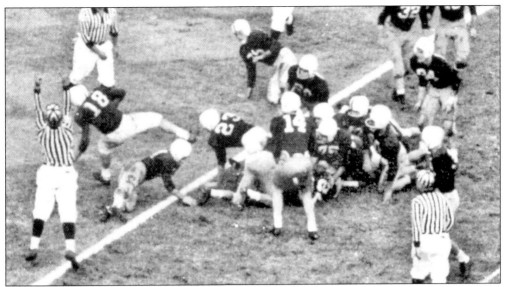

VICTORY IN 1955. In 1955 the Tigers repeated a shutout of "hapless Alabama" with a score of 26-0. As noted in the yearbook, "Guards Chuck Maxime and Ernest Danjean were the stars up front. They constantly bore down on Bama's passing ace, Bart Starr, and never gave him a chance to show the passing attack which had been expected."

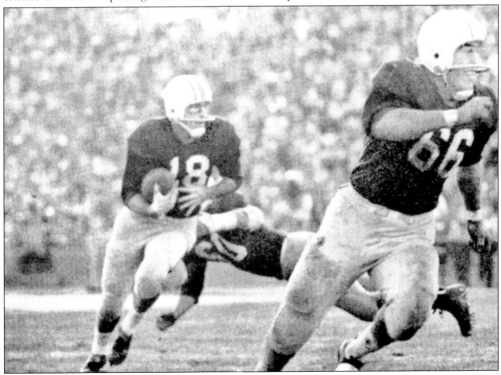

THREE IN A ROW, 1956. The Tigers' streak continued for a third win with a 34-7 thrashing of Bama in which "Auburn rode the strong right arm of Howell Tubbs and the flying feet of Bobby Hoppe." The Tigers defense "rolled with such clockwork precision that Tide Coach J.B. Whitworth declared the Tigers as the best team he had seen all year."

FIVE IN A ROW, 1958. Auburn beat Bama for the fifth year in a row in 1958. The 1957 national championship team had soundly whipped the Tide 40-0 the year before. The Tigers played "in grand style as they humbled a strong University of Alabama team 14-8 before a sellout crowd of 44,000" at Legion Field. This win was the 24th consecutive game in which Auburn did not lose (they tied with Georgia Tech 7-7 this season). Jimmy Pettus, pictured, scored Auburn's first touchdown in this game.

VICTORY IN 1963. After four years of disappointing defeats, the Tigers vanquished Bama 10-8. "Auburn rode the strong arm of Mailon Kent and the kicking foot of Woody Woodall" to beat a Bama team that included Joe Namath. "Auburn's defense gave no leeway on the ground or in the air." Punter Jon Kilgore is pictured here.

1969 WIN. Auburn's fortunes returned when the Tigers slammed Bama 49-26. Mickey Zofko is shown pushing past a Bama player attempting to tackle him at the three-yard line to score a touchdown in the fourth quarter. The team fulfilled its goal of ensuring Bama's team, coaches, and fans "had gotten a good long look at football Tiger style."

TWO IN A ROW, 1970. The Tigers made it two wins in a row when they prevailed over Bama 33-28. Alabama led until the third quarter, when Pat Sullivan tied the score. Both teams then successfully made field goals. Auburn gained the lead and kept Bama from scoring by intercepting two passes.

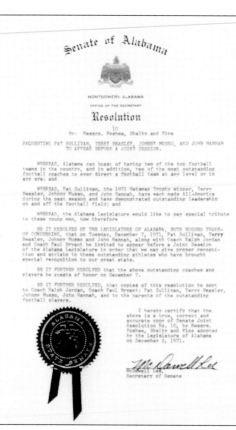

Senate of Alabama

MONTGOMERY, ALABAMA
OFFICE OF THE SECRETARY

Resolution

10

By: Messrs. Foshee, Shelby and Fine

REQUESTING PAT SULLIVAN, TERRY BEASLEY, JOHNNY MUSSO, AND JOHN HANNAN
TO APPEAR BEFORE A JOINT SESSION.

WHEREAS, Alabama can boast of having two of the top football
teams in the country, and in addition, two of the most outstanding
football coaches to ever direct a football team at any level or in
any era; and

WHEREAS, Pat Sullivan, the 1971 Heisman Trophy winner, Terry
Beasley, Johnny Musso, and John Hannah, have each made All-America
during the past season and have demonstrated outstanding leadership
on and off the football field; and

WHEREAS, the Alabama Legislature would like to pay special tribute
to these young men, now therefore

BE IT RESOLVED BY THE LEGISLATURE OF ALABAMA, BOTH HOUSES THERE-
OF CONCURRING, that on Tuesday, December 7, 1971, Pat Sullivan, Terry
Beasley, Johnny Musso and John Hannah, along with Coach Ralph Jordan
and Coach Paul Bryant be invited to appear before a Joint Session
of the Alabama Legislature in order that we may give proper recogni-
tion and acclaim to these outstanding athletes who have brought
special recognition to our great state.

BE IT FURTHER RESOLVED that the above outstanding coaches and
players be guests of honor on December 7.

BE IT FURTHER RESOLVED, that copies of this resolution be sent
to Coach Ralph Jordan, Coach Paul Bryant: Pat Sullivan, Terry Beasley,
Johnny Musso, John Hannah, and to the parents of the outstanding
football players.

I hereby certify that the
above is a true, correct and
accurate copy of Senate Joint
Resolution No. 10, by Messrs.
Foshee, Shelby and Fine adopted
by the Legislature of Alabama
on December 2, 1971.

McDowell Lee
Secretary of Senate

EQUAL RECOGNITION. The Alabama Senate passed a resolution praising both Auburn's and Alabama's exemplary players and coaches representing the 1971 teams. Shug Jordan donated his copy of the resolution to Auburn's archives.

1972 WIN. Going into the 1972 game, Alabama was 10-0 and national championship contenders. Auburn was behind 16-0 in the fourth quarter when David Langner's recovery and return of two blocked Alabama punts to score two touchdowns and a field goal by Gardner Jett assured Auburn a 17-16 victory on December 2, 1972. Fan Alma Smith Stoves (Class of 1919) said that watching Auburn play that day was "the biggest thrill I've ever gotten out of a football game . . . I tell you I was paralyzed. I didn't even realize it when it was over. If we lived another 1,000 years that game couldn't be repeated." She humorously remarked, "I've never seen anybody more disgusted than Bear Bryant was that Sunday afternoon." Auburn fans proudly put "Punt Bama Punt" bumper stickers on their vehicles.

1982 VICTORY. Bo Jackson made his infamous dive over the Alabama goal line to win the game for Auburn 23-22. Lionel James, Randy Campbell, and Al Del Greco accumulated Auburn's score to 17-22 by the fourth quarter when Bo leapt to give Auburn the win. Auburn's defense held by the Tide for the agonizingly long remaining two minutes and 26 seconds. The victory was especially welcome because Auburn had suffered nine consecutive Iron Bowl losses. Bumper stickers proclaiming 23-22 were seen across the state. Bear Bryant decided to retire after this game.

1983 WIN. Pat Dye's Tigers beat Bama for a second year in a row, celebrating with a 23-20 win and the SEC Championship. Bo Jackson set a rushing record of 256 yards in this game. The 11-1-0 season concluded with Auburn's Sugar Bowl triumph.

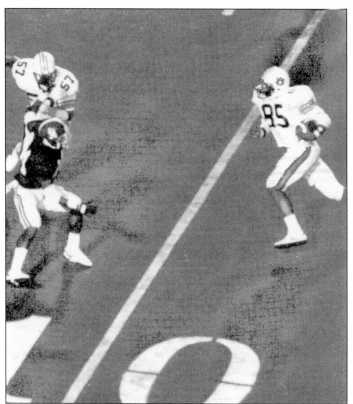

VICTORY IN 1986. After two close losses to Bama, a four-game winning streak in the Iron Bowl began with Auburn's 21-17 victory in the 1986 game. Lawyer Tillman and Brent Fullwood were outstanding Tiger players in this game. Auburn closed the season with a 10-2-0 record.

AGAIN IN 1987. Auburn confidently secured its victorious 10-0 match, its second Iron Bowl win in a row, against its archrival in 1987. Auburn won the SEC Title and was invited to the Sugar Bowl, finishing with a 9-1-2 record. Dye was named SEC Coach of the Year.

1988 WIN. Defensive end Tracy Rocker is shown in action when Auburn beat Bama 15-10. Having beaten Alabama three years in a row, the 10-2-0 Tigers repeated their SEC Championship and Sugar Bowl bid. In 1988, Rocker became the first SEC player to win both the Outland and Lombardi Awards in the same season and was inducted in the College Football Hall of Fame in 2004. Dye again was SEC Coach of the Year.

HOME IS WHERE THE HEART IS. On December 2, 1989, number two Bama with a 10-0 record played on the Plains against number 11 Auburn with an 8-2 record. With Alabama's quarterback at his feet, linebacker Craig Ogletree was ecstatic because he had sacked him. The physical Tigers defense showed Alabama that it had the courage and tenacity to make Jordan-Hare a hostile territory for the Crimson Tide. Auburn people on the field and in the stands were devoted to beating Bama on the Plains that day and in every future Iron Bowl at Auburn.

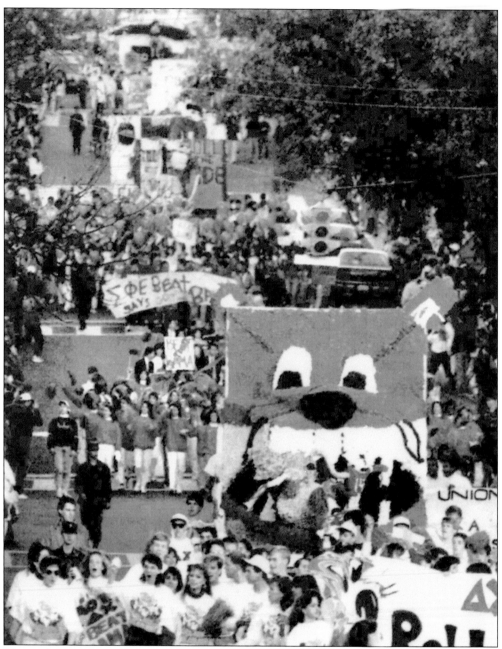

HOME, SWEET HOME. Even though Shug Jordan asked Alabama to play at Auburn for years, Bear Bryant and Alabama officials argued that Bama would not play there because they claimed the stadium was too small and the roads to Auburn insufficient. Auburn officials dismissed Bama's reasons, stating that the stadium had been expanded and highways built. After Bryant died in 1983, Coach Dye negotiated a compromise to alternate playing the Iron Bowl at Auburn and Alabama's designated home fields. Steve Sloan, Bama's athletic director, was fired when he accepted Dye's deal. More than 4,000 people marched in or watched the "Beat Bama at Home" parade and cheered at the Plainsman Park pep rally. During the Tiger Walk, 20,000 Auburn fans cheered the team. A record 85,319 crowd watched Auburn beat Bama 30-20.

THERE'S NO PLACE LIKE HOME. Auburn fans rejoiced at being able to walk directly from Jordan-Hare Stadium where they had just seen Auburn beat Bama to Toomer's Corner where they could celebrate that win and Auburn's third consecutive SEC Championship with thousands of other happy Tigers.

1995 WIN. Auburn beat Alabama at Jordan-Hare in an emotional 31-27 game. Ahead 24-14 at halftime, Auburn risked defeat when Alabama players added 13 points to their score. Another touchdown by Fred Beasley put Auburn in the lead. An out-of-bound Bama completed pass put pressure on the Tigers to prevent the Crimson Tide from scoring on remaining plays near their goal. After the clock ran out, Auburn fans stayed in the stadium, yelling, "It's great to be an Auburn Tiger." Team members jubilantly carried the Auburn spirit flag onto the field.

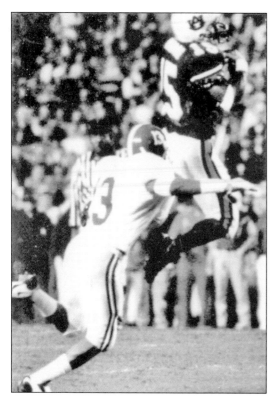

VICTORY IN 1997. In a suspenseful game that was not resolved until the final moments, Auburn bested Bama 18-17 at Jordan-Hare. Jaret Holmes's foot earned Auburn six field goal points, which Bama surpassed, racking up 17 points. Fred Beasley scored a touchdown, and Holmes made another field goal. Auburn was behind 15-17 with 15 seconds left on the clock. Holmes came through for the Tigers, kicking the ball for three additional points. Clifton Robinson is shown jumping high over a defensive Bama player in order to grab the football.

VICTORY IN 2000. Despite icy-cold rain, Damon Duval successfully kicked three field goals to secure Auburn's 9-0 victory over Bama. The Tigers delighted in their win at Auburn's debut game at Bryant-Denny Stadium. The last time Auburn had played in Tuscaloosa was 1901 when the Tigers won 17-0.

EIGHT

National Champions

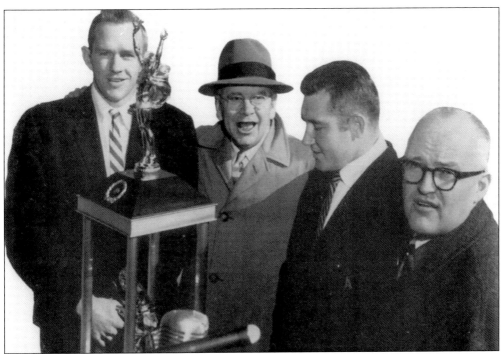

IT'S GREAT TO BE AN AUBURN TIGER! Co-captain Jimmy "Red" Phillips, Auburn president Ralph B. Draughon, co-captain Tim Baker, and Associated Press sports editor Ted Smits celebrate Auburn's National Football Championship trophy . The team also won Auburn's first SEC title and savored Auburn's first perfect season since 1913. Phillips and team members earned many other individual honors as a result of their National Championship season. Phillips was named an All-American and was a first-round draft pick by the Los Angeles Rams. Because of his college gridiron accomplishments and his career playing and coaching professional football, he was inducted in the Alabama Sports Hall of Fame.

GLIMPSE OF THE FUTURE. Auburn's undefeated 1954 freshman team coached by Dick McGowan offered the promise of great things for Auburn football. The *Glomerata* confidently stated, "Presenting one of the greatest freshman teams ever assembled on the Plains, the 1954 edition of the Baby Tigers swept by their opponents with a spotless record" with players that "make the team one of future promise." With a "streamlined offense, and stonewall defense," the team beat Georgia, Alabama, and Georgia Tech. "One only has to glance at the records amassed by this fine team," the yearbook asserted, "to become aware of the fact that the future holds some rough Saturday afternoons for the other eleven teams of the Southeastern Conference—afternoons that are going to be pleasant ones for Tiger followers." These future National Champions are pictured left to right as follows: (front row) the "hard charging line"—Jimmy Phillips, Ben Preston, Gary Snider, Billy Pappanastos, Tim Baker, Sonny Norred, and Jimmy Reece; (back row) the "powerful and deceptive backfield"—Jimmy Roach, Billy "Ace" Atkins, Jimmy Cook, and Bobby Hoppe.

ONE WIN, ZERO LOSSES. Auburn beat Tennessee 7-0 at Knoxville in the rain on September 28, 1957. Billy "Ace" Atkins is shown running for a touchdown. Tennessee had been the 1956 SEC champions. Sam Adams reported in the *Alabama Journal*, "Auburn beat the favored Tennessee Vols at their own game—alertness and terrific defensive play."

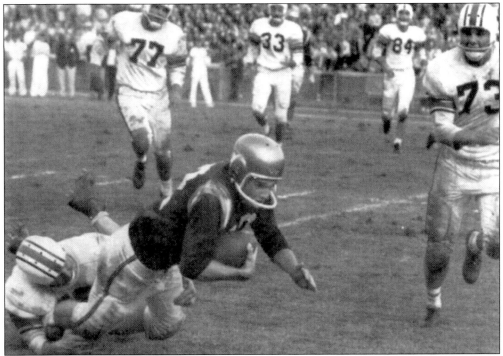

TWO WINS, ZERO LOSSES. The "highpowered" Tigers effectively defeated the Chattanooga Moccasins 40-7 at Auburn on October 5. Forty-three players, representing four units, took the field during the game, and Auburn scored points in each quarter.

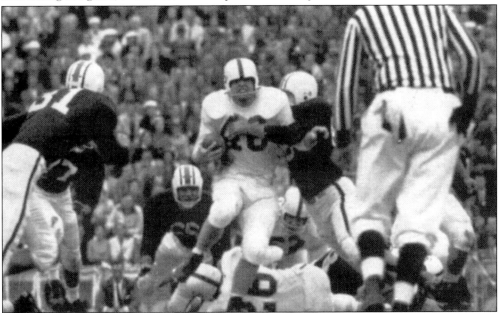

THREE WINS, ZERO LOSSES. Auburn won 6-0 when Kentucky came to Cliff Hare Stadium on October 12. An estimated "30,000 nerve-wrecked fans" watched a "scoreless first half." Atkins scored Auburn's touchdown, and the defense prevented Kentucky from crossing Auburn's 17-yard line.

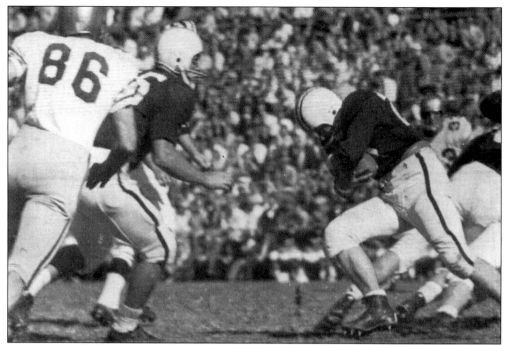

FOUR WINS, ZERO LOSSES. Playing in Atlanta, Auburn beat Georgia Tech 3-0 on October 19. Atkins "kept Tech deep in its own territory" with his "high punts all afternoon." The "Tigers proved again their No. 1 national defensive rank by allowing Tech only 148 yards, total offense."

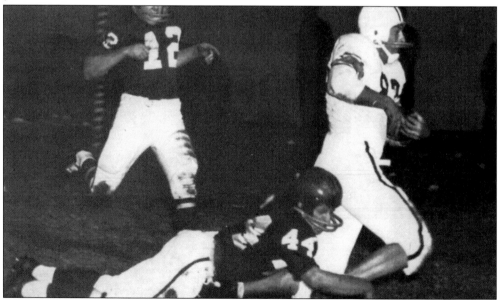

FIVE WINS, ZERO LOSSES. Traveling to Houston, Texas, the Tigers defeated Houston 48-7 on October 26. Spoiling Houston's Homecoming, the Tigers played "one of their best performances" by "taking the steam out of the Houston team" from the opening play. "This oil town," the *Glomerata* stated, "will be echoing the War Eagle battle cry and rocking from an offensive explosion in Rice Stadium for quite a while." Hindman Wall is shown scoring.

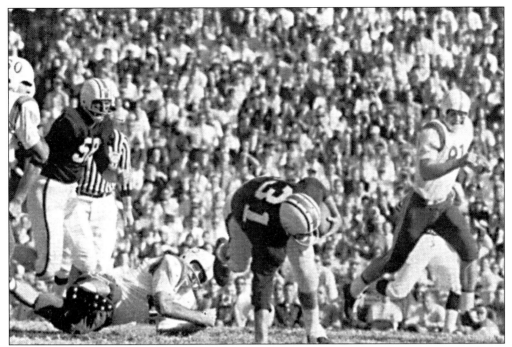

SIX WINS, ZERO LOSSES. Auburn beat Florida 13-0 at the Homecoming game on November 2. Cliff Hare Stadium was "overflowing" with fans who watched Phillips win the Blue Key's outstanding player award on which sports writers had voted. This honor foreshadowed Phillips being named an All-American by season's end.

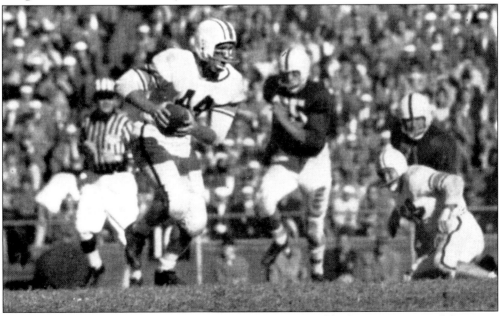

SEVEN WINS, ZERO LOSSES. At Birmingham's Legion Field, the Tigers won 15-7 against Mississippi State on November 9. Auburn rallied in the second half to win. The "Number One defense in the Nation" prevented Mississippi State's main quarterback from throwing completed passes and "held [him] to minus yardage."

EIGHT WINS, ZERO LOSSES. Auburn defeated the Georgia Bulldogs 6-0 in a November 16 match at Columbus Memorial Stadium. The yearbook states, "The War Eagles, who entered the game as the nation's leading exponents of defense, allowed the Bulldogs only three first downs." Statistics also showed Auburn's defensive strength by limiting Georgia to 97 yards: 23 passing and 74 rushing.

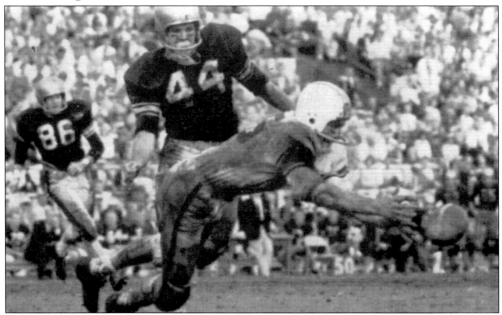

NINE WINS, ZERO LOSSES. The Tigers outplayed Florida State University 29-7 at Tallahassee on November 23. Atkins "broke the school scoring record for one season as he slammed for two touchdowns and booted two extra points." Florida State's touchdown was the fourth and final time an opponent scored against Auburn during this season.

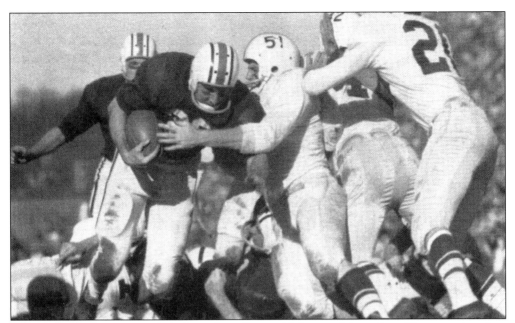

TEN WINS, ZERO LOSSES! Auburn beat Bama 40-0 in a November 30 game played at Birmingham's Legion Field. When the fourth quarter ended, Auburn fans yelled, "We're Number One!" By Monday, the Associated Press stated: "Auburn, the unbeaten, untied giant of the Southeastern Conference . . . became the first winner of the Associated Press National Football Championship Trophy. The Tigers, whose sturdy defense yielded only four touchdowns in 10 games, drew a landslide vote in the final poll of the season." Future astronaut and student body president Thomas Mattingly (Class of 1958) led a spontaneous pep rally as news of Auburn's national title swept campus.

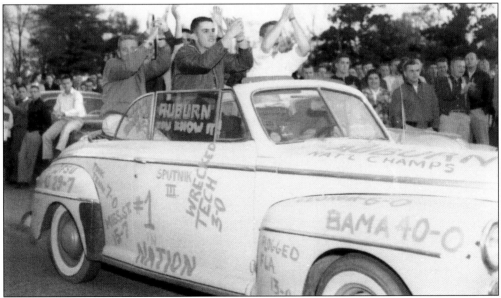

PERFECT SEASON. National Champion players and coaches enjoyed riding in decorated cars during parades celebrating their achievement. The team selected Atkins as the season's most valuable player. He later coached a National Championship team at Troy State University.

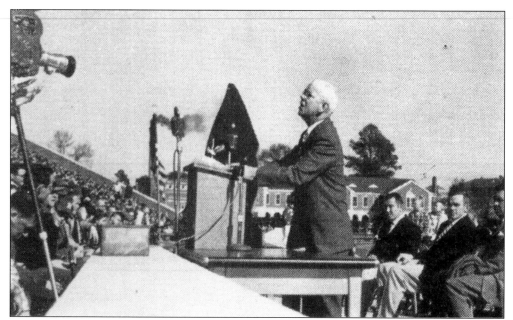

Praise. Auburn President Ralph B. Draughon addressed fans when a large crowd gathered on what was declared "Auburn Day." He congratulated the Tiger coaching staff and team. Everyone admired Auburn's National Championship trophy. Auburn's band played pep songs as the crowd rejoiced.

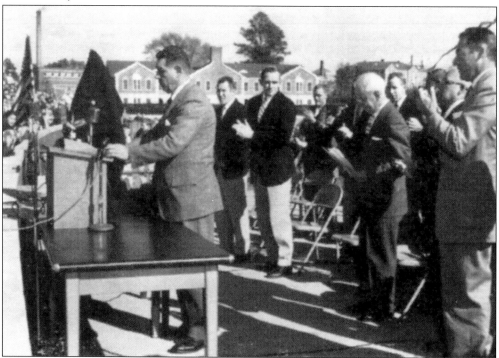

Celebration. Coach Shug Jordan took his turn at the microphone. He thanked Auburn's students for providing spirit and support for the team. Everyone in Auburn was proud of the team and of Jordan, who was named National Coach of the Year.

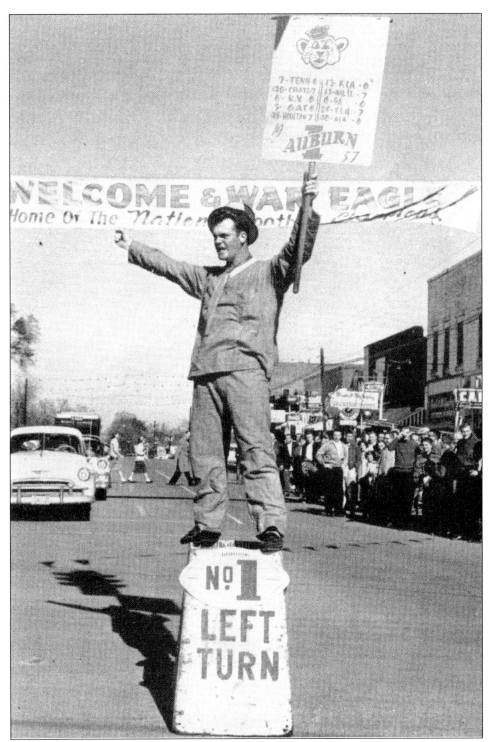

WE'RE NUMBER ONE! Jubilant fans flocked to Toomer's Corner to share their joy at Auburn's national achievement. Imagine what downtown Auburn would have looked like if the tradition of rolling Toomer's Corner had existed in 1957!

SADDLE SHOES AND SPIRIT. The 1957 cheerleaders boosted the Auburn spirit by leading crowds to yell loudly and encourage players to win a National Championship for Auburn. Bob Hurt is in front of fellow squad members: (left to right) Faye Mitchell, Rodney Summers, Rosamond Freemond, Don Fay, and Jule Huey. Mark Goodwin also belonged to this cheerleading team.

CHAMPION PEP. Auburn's cheerleaders energetically and imaginatively expressed their spirit to contribute to the achievements of the 1957 National Championship season.

PRIDE. Auburn's Alpha Tau Omega fraternity won the 1958 Homecoming float contest with this large crepe paper and chicken wire replica of Auburn's National Championship trophy.

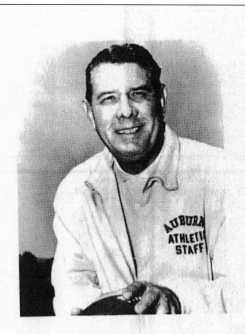

COACH RALPH "SHUG" JORDAN

North Alabama Appreciation Day Banquet

JANUARY 30, 1976

VON BRAUN CIVIC CENTER

Huntsville, Alabama

HERO. In the years after his National Champion season, Coach Jordan was frequently asked to speak and appear at banquets and other programs throughout Alabama and elsewhere. As Auburn's most-winning coach, Jordan and his teams set long-standing records that gained them respect throughout the sporting world. He was posthumously inducted in the College Football Hall of Fame in 1982.

AUBURN
Football Illustrated

Special Edition Commemorating the 1957 National Championship

The Arizona Game

September 10, 1977 Jordan-Hare Stadium

$1.00

GLORY. This commemorative football program for the 1977 season opener honored the 1957 team 20 years after they won the National Championship. Auburn beat Arizona 21-10 that day. Coaches and members of the National Championship team are held in high esteem at Auburn. They make special appearances and gather at reunions. Several people associated with that team were inducted in the Alabama Sports Hall of Fame in addition to receiving national and local honors.

ROLE MODEL. Coach Jordan is pictured with a bust presented to him at the A-Day game on May 8, 1976. Since then, Auburn teams aspire to win another National Championship by emulating Jordan's commitment to Auburn football. Jordan remains fans' most revered coach. In 1992, he was voted Coach of the Century for Auburn's centennial team. His coaching methods, respect for players and staff, and love for football inspires everyone who believes in Auburn football. When Jordan died on July 17, 1980, flags in Auburn were lowered to half-mast and stores closed as the town mourned the "patriarch of Auburn football." An early *Glomerata* printed a statement that holds true for all generations of football on the Plains: "The season ended like every good thing must, but our memory will always cherish the valor of these men that played the game for the old Alma Mater. . . . Long Live King Football!"